AMERICAN ART & ARTISTS

Series Editor: BRENDA GILCHRIST

GEORGE INNESS

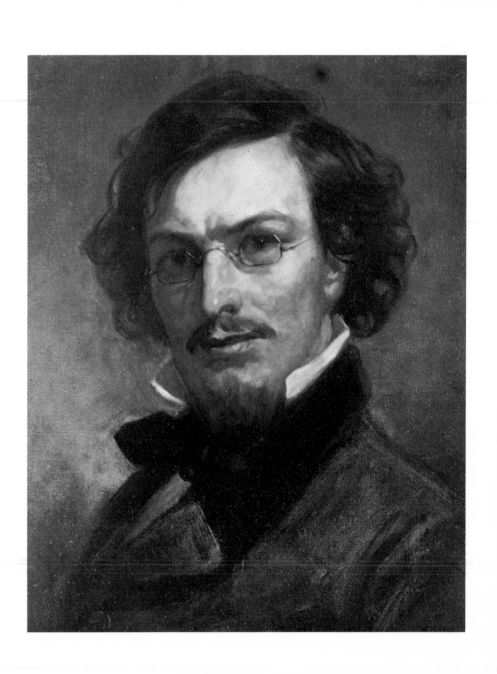

GEORGE INNESS

NICOLAI CIKOVSKY, JR.

PRAEGER PUBLISHERS

NEW YORK · WASHINGTON · LONDON

Credits

The publishers acknowledge with thanks the following institutions for granting permission to quote from letters in their possession: the Albany Institute of History and Art, Albany, New York; the Archives of American Art, Smithsonian Institution, Washington, D.C.; The Boston Public Library, Boston, Massachusetts; the Harvard College Library, Harvard University, Cambridge, Massachusetts; The Historical Society of Philadelphia, Philadelphia, Pennsylvania; The Montclair Art Museum, Montclair, New Jersey; the Museum of Fine Arts, Boston, Massachusetts (Sylvester R. Koehler Collection); The New-York Historical Society, New York, New York; and the Princeton University Library, Princeton, New Jersey.

26817

FRONTISPIECE. Daniel Huntington. *Portrait of George Inness. ca.* 1853. Oil on canvas, 20 x 16 inches.
Permanent Collection, National Academy of Design, New York.
Photo Frick Art Reference Library, New York.

PRAEGER PUBLISHERS
111 Fourth Avenue, New York, N.Y. 10003, U.S.A.
5, Cromwell Place, London S.W.7, England

Published in the United States of America in 1971
by Praeger Publishers, Inc.

© 1971 by Praeger Publishers, Inc.

Library of Congress Catalog Card Number: 79–117471

Printed in the United States of America

To Emily

CONTENTS

LIST OF ILLUSTRATIONS

ACKNOWLEDGMENTS

It would be impossible to list, much less to thank adequately, the many persons and institutions that have assisted me with this study over the years. I must express my gratitude to all those who permitted me to illustrate works in their collections or in their charge, and to the staffs of the Boston Public Library (particularly the staff of the Patent Room); the Fogg Art Museum Library and Houghton Library, Harvard University; the Frick Art Reference Library, New York; The New-York Historical Society Library; The New York Public Library (and Newspaper Annex); and the Princeton University Library.

The following persons were unusually kind and helpful: Garnett McCoy and Dr. Regina Soria of the Archives of American Art; Morton Vose; Walter Fillin; Dr. David Huntington; Thomas J. McCormick; Ellen Moers; and John L. Ward.

I owe an enormous and very special debt of gratitude to the late LeRoy Ireland, the foremost authority on Inness and compiler of the indispensable *catalogue raisonné* of his works, who most graciously and generously gave of his knowledge, kindness, and hospitality. Without his material and inspirational help, this study could not have been written.

Finally, to Professors Frederick B. Deknatel and Benjamin F. Rowland, Jr., of Harvard University go my profoundest thanks for their assistance with the thesis from which this book has been distilled, as well as for more than a decade of confidence and encouragement.

NICOLAI CIKOVSKY, JR.

Vassar College
Poughkeepsie, New York, May, 1971

GEORGE INNESS

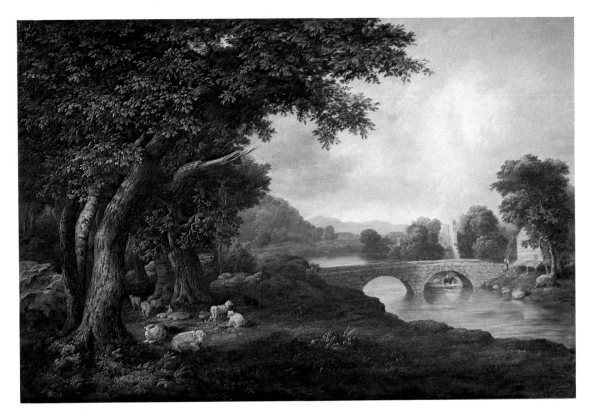

PLATE I. *Landscape*. 1848. Oil on canvas, 30 x 45 inches.
California Palace of the Legion of Honor, Lincoln Park, San Francisco;
Mildred Anna Williams Collection (Gift of H. K. S. Williams).

PLATE II. *Clearing Up*. 1860. Oil on canvas, 15¼ x 25⅜ inches.
George Walter Vincent Smith Art Museum, Springfield, Massachusetts.

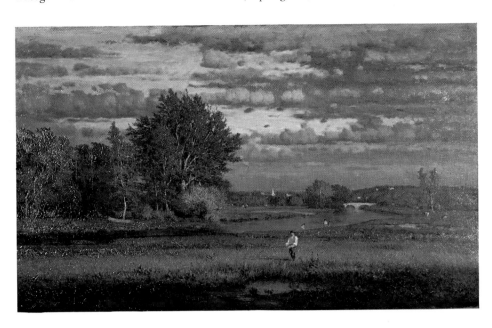

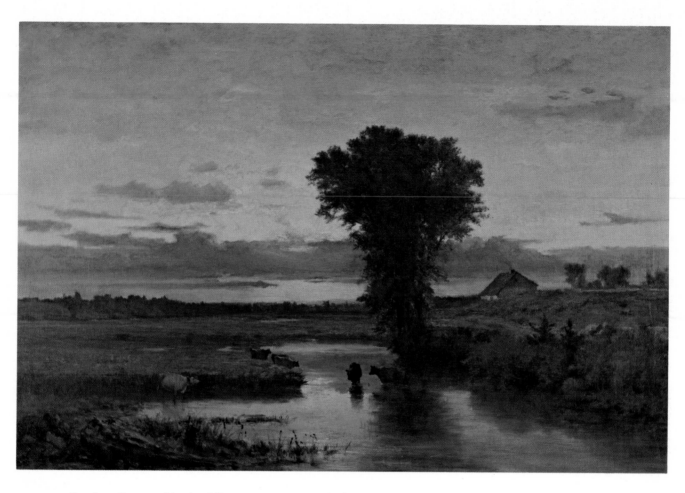

PLATE III. *Brook at Sunset*. 1861–64. Oil on canvas, 25 x 37 inches.
Cincinnati Art Museum, Cincinnati, Ohio; Bequest of Harry S. and Eva Bell Leyman.

GEORGE INNESS

George Inness has remained to the present time one of the most neglected major American artists of the nineteenth century. He is not unrecognized; on the contrary, he is dutifully mentioned in every discussion of the period, but such mention is usually brief, more grudging than enthusiastic, and commonly made in connection with other, often inferior, artists.[1] However, during his lifetime and the decade or two following his death, he was not merely given frequent and extended notice but was considered by many to be America's foremost landscape painter. In 1881, for example, it was claimed that he "is one of the few really great landscape painters of his day and generation" and that he "has a world-wide reputation" and "ranks with Daubigny, Carot [sic], and Courbet, and in his best work has shown not merely full talent, but unmistakable genius. . . ."[2] In 1888, Inness was "generally allowed by the verdict of the whole art world to occupy a foremost place among the world's landscape artists."[3] And in 1895, a few months after his death, he and Winslow Homer were praised as the "men who first gave pictorial voice to what we stand for in this Western world." "Honor to them both," the writer concluded.[4]

The subsequent decline in Inness's reputation was part of a general disenchantment in the late nineteenth and early twentieth centuries with the school to which his own style of painting was unmistakably related, namely the French Barbizon School.[5] From this point of view, Inness may be regarded as a victim of changing tastes. He is not, however, entirely blameless for his loss of stature in the twentieth century. His paintings, particularly the late ones, lack the usual charm of scenery or the interest in locality and incident that commonly make landscape paintings appealing. Inness felt no great desire to depict particular places, and when asked where a landscape was painted, he

replied, "Nowhere in particular. Do you think I illustrate guide books? That's a picture." [6] Moreover, he felt free to manipulate, even to ignore, the colors, forms, and arrangements of nature for his own ends. "My forms," he said, "are at my finger tips as the alphabet is on the tongue of a schoolboy." [7] It was also said of him that he "painted within the four walls of the room, away from and without reference to any particular nature; for he himself was nature." [8] Such remarks reveal the artist's deep devotion to the formal, rather than illustrative or narrative, properties of art. His primary dedication was to the mechanism of color and shape itself, and only secondarily to what it could depict or express: "A story told by a painter," he said, "must obey the laws of pictorial art. The painter tells his story with the delicacies of his *chiaroscuro*, with the suggestions of his form." [9] It is precisely this formalism—noted disapprovingly by his contemporaries—that makes Inness perhaps the most "modern" American painter of the late nineteenth century, for it was this acknowledgment and use of the aesthetic and expressive properties of form that allied him to the more advanced French painters of his generation. It is therefore ironic that the twentieth century, so sensitive to the formal dimensions of art, should be unable to see or to commend this aspect of Inness's painting.

George Inness was born on May 1, 1825, in Newburgh, New York, [10] to which his father, John William Inness, a prosperous grocer, had retired for reasons of health. [11] He evidently recovered it soon after George's birth, for the family returned to New York City shortly thereafter and his father resumed his business. They lived there until 1829, when they again moved to the country—this time to Newark, New Jersey. George attended the Newark Academy briefly, but his formal education was minimal. When he was about fifteen, his father tried to launch him on a career in business, as he had managed to do with most of his other sons, but George had already determined to become an artist. And so, probably in 1841, his father placed him with John Jesse Barker (active 1815–56), an itinerant artist then residing in Newark, who was to be Inness's first instructor. Barker was a mediocre artist, and Inness studied with him only for a month or so, receiving little more than a rudimentary knowledge of art. Yet Barker should not be dismissed too lightly, for perhaps it was he who set Inness upon the artistic course he would follow for the rest of his life.

When Barker arrived in Elizabethtown, New Jersey, in 1820, he announced his presence and publicized his skills by saying he had "enjoyed the instructions of Mr. [Thomas] Sully, one of the most successful painters of likenesses of the

present day." [12] Barker's paintings (*Ill. 1*) display none of the brilliance and facility that are so conspicuous in Sully's works, but it is possible that he passed on to his pupil certain elements of Sully's painterly style, thereby exposing Inness in the first stages of his career to the rich effects of pigmentation and brushwork in which he never lost interest.

After his brief sojourn with Barker (though at what point in time is not certain), Inness learned some quite different lessons as an apprentice engraver in the firm of Sherman & Smith in New York. He worked for them "off and on for two years," [13] he reported ("a little tinkering in an engraver's office," he later called it), [14] and while this was longer than he would spend on other stages of his artistic education, the experience had the least effect on him. This is not remarkable, for the painstaking work of engraving suited neither his nervous temperament nor his predilection for color and painterly textures. Many years later, in 1879, while experiencing difficulties working on an etching, he described "pecking with a graver" as "such long winded tiresome work." [15]

Following these two unfruitful years with Sherman & Smith, there came a more formative and influential experience for Inness: a brief period of study with Régis François Gignoux (1816–82), a French artist who had come to New York around 1840. Inness said he studied with Gignoux when he was "about twenty," [16] that is, in 1845. But if, as seems likely, 1841 was the year he studied with Barker, and if he spent the succeeding two years with Sherman & Smith, he could have studied with Gignoux as early as 1843. Although this contradicts Inness's testimony (made many years after the fact and understandably imprecise), it has to recommend it the fact that in the spring of 1844, he made his professional debut by contributing two paintings to the annual exhibition of the National Academy of Design in New York, while in 1845, he again sent a painting to the Academy and also had his work accepted for distribution by the American Art-Union. It is unlikely that he would have sought instruction while feeling sufficiently confident to exhibit and after being judged competent enough to receive recognition from the Art-Union.

Gignoux had a deep, if not readily visible, influence on the course of Inness's early work. Before considering this, however, certain aspects of Inness's life and personality must be mentioned. Most of the information we have about his early life comes from two later autobiographical statements. [17] In both, the artist mentions an omnipresent factor in his youth: ill health. He was "sick during the whole of early life," and "When about twenty I had a month with Gignoux, my health not permitting me to take advantage of study at the academy in the evenings." Inness's illness must be discussed not simply because

it was such a prevalent feature of his early life, but because it influenced the character of his life as a whole—a life, as he revealed in 1884, "bourn [*sic*] under the distress of a fearful nervous disease." [18] His disease (epilepsy) did not profoundly affect his art, nor does it in any way explain it; but it did and, in a way, still does have an effect on his biography and therefore must be considered. We have very little personal information about Inness. Material has been lost in one way or another, and Inness himself mentioned his "general disinclination to write letters." [19] Yet one senses, too, as Elizabeth McCausland said, that "his epilepsy caused Inness's family to erect more than usually thorny shelters about his fame." [20] The "official" biography by his son, George Junior,[21] for example, mentions poor health repeatedly but never names Inness's affliction; moreover, it relies more on the public testimony published by others than on private material in the author's possession. And the picture one gets of Inness from reminiscences of friends and pupils is, though colorful, for the most part respectfully two-dimensional.

Another reason for the scarcity of information about Inness is that for much of his life he lived in the country or suburbs, comparatively isolated from the social and professional functions of the city and therefore infrequently mentioned in memoirs or accounts of artistic life. However, the most important reason for his avoidance of city life was surely his poor health.

The year 1844, in which Inness first exhibited at the National Academy of Design, marks the beginning of his professional life. Judging from the events of the following years, he quickly attained at least a modest success. He continued to show regularly at the Academy almost without interruption until the end of his life, and at the Art-Union until its demise in 1851. By 1846, he was exhibiting as many as four paintings at the Academy and five at the Art-Union. In the next year, in addition to having four paintings each at the Academy and Art-Union, he attracted his first patron, Ogden Haggerty, a wealthy New York auctioneer with a deep interest in art. Haggerty appears with some regularity, as early as 1832, as a lender to Academy exhibitions,[22] and was also a member of the Art-Union and the Century Club. His interest in Inness was not simply the caprice of a wealthy man attracted by some pleasing features in the work of a young painter, but flattering recognition of Inness's talent from a connoisseur of art. It is an indication, too, that after only three years of professional practice, Inness's ability was conspicuous enough to attract such attention.

Haggerty not only purchased Inness's paintings but also financed his foreign study. It is frequently said that Inness's first trip to Europe, paid for by Haggerty, was made in 1847,[23] but there is no real evidence that this is so. Inness

exhibited at the Academy and Art-Union in this year, and none of his paintings were of European subjects. In 1882, Inness wrote that he had made "three trips to Europe." [24] Each of these may be accounted for, and none occurred in 1847. In 1884, Inness remarked, "In 1850 I was married to my present wife. Mr. Ogden Haggerty who had already greatly assisted me allowed me a certain sum for study in Europe," [25] thus clearly implying that this study did not predate 1850.

In 1847, Inness received his first published criticism in a review of the Academy exhibition in *The Literary World*. While calling him "a young artist of good promise," the critic was not entirely pleased with two of Inness's paintings and was particularly sharp with one of them, *The Lament*: "We cannot perceive the significance of the name given to this picture, unless it means that the artist laments having painted one so bad." [26]

In 1848, Inness had six paintings at the Academy, all of them privately owned (two by Haggerty). He was again mentioned in *The Literary World*, not yet enthusiastically but less severely than before ("Several landscapes by Mr. Inness show an advance from last year.")[27] Sometime during this year, he also took his own studio in New York.

It seems from all of this that Inness's fame, and even his fortune, were rising rapidly. This was particularly evident in 1849, when he sold five paintings to the Art-Union, setting—and evidently, in one case, receiving—unusually high prices for them. Perhaps disdaining it as unremunerative, he sent nothing to the Academy that year. A letter to the purchasing committee of the Art-Union reveals the extreme self-confidence he felt at this time:

> . . . although you may think $400 a large sum for a picture by a young artist, yet as on this picture, I have spent every effort, and sustained considerable loss by not painting small pictures[,] I cannot help feeling as if I should have a little more than you offer. The present price will not pay me at the same rates as you paid for my "Peace & War" [an 1848 painting, now lost] of which I could easily, while painting this, have painted four and sold two at private sale for $200 each. I do not wish to upbraid you as desiring to get the picture at under value for none but Mr. Geo. Austin [a member of the committee] have seen the picture either finished or framed[;] a just estimate of it therefore cannot be made. If now the committee will be so kind as to call and see the picture as it stands I think they may be willing to give me my full price or at least what I named to Mr. Austin as my lowest one.[28]

The picture is not referred to by name, so that we cannot tell if Inness's confidence—or price—was justified. *Hills of Berkshire*, a work of 1848, is the largest he painted at this time and may be the one in question. He did say

later that he once received as much as \$350 from the Art-Union,[29] which, if it was for this picture, means he got almost the price he asked. Moreover, if he could easily sell small paintings privately for \$200, as indicated in the above statement, he was doing quite well indeed.

Later in 1849, Inness offered the Art-Union another painting, *Religion Giving Peace to the World* (which they did not accept). Though it has disappeared, it is noteworthy as an indication of the artist's deep religious feelings. "In 1849," his son reports, "we have record that he joined the Baptist Church and was baptized in the North River."[30] Although he would not remain a Baptist, and although it would be some time before he found in the teachings of Swedenborg a religious doctrine that satisfied him, he was always concerned with religion and metaphysics, so much so that his brother James recalled, "at one time he told me that in his early days, if his health had permitted, he would have become absorbed in metaphysical studies."[31] One of Inness's earliest (anonymous) biographers said, "If he had not possessed an intense love of form and a wondrous sense and power of expression of color, he would have been a preacher or a philosopher in another way, for he has a deep religious nature and an extraordinarily analytical philosophical mind."[32] Inness himself admitted in an interview of 1894 that theology was "the only thing except art which interests me."[33] In 1882, he said of metaphysical speculation, "Years ago, if I had only had money, and hadn't had to paint, I should have gotten into a lot of all this kind of thing."[34]

Inness's religious enthusiasm may certainly be traced to his family. His mother was a "zealous Methodist," his stepmother "an equally zealous Baptist, and her brother . . . an ardent and proselytizing Universalist."[35] But Inness took a different direction, for if he gave the impression by his intensity of being a religious zealot, his deepest attachment was to the philosophy rather than the practice of religion. He relished religious disputation, but he was not interested in proselytizing, having little use for religion in its ritualistic and sectarian forms: ". . . he never formulated for himself a theological creed, because, as he said, a man's creed changes with his states of mind, and the formulation made today becomes useless tomorrow."[36]

In 1850, Inness married for the second time (of his first youthful marriage to Delia Miller of Newark, nothing is known or discoverable). The critic Montgomery Schuyler, Inness's most sensitive and reliable biographer, calls this second marriage "very probably a reckless performance, from the point of view of worldly prudence."[37] Yet his financial situation was quite secure at that time, and his marriage, rather than being a reckless act, was a clear expression of his confidence and success.

Elizabeth Hart was seventeen years old when she married Inness, eight years her senior. Beautiful, capable, and the perfect complement to her husband —she solid and sensible, he impulsive and improvident—she bore six and raised five children, endured constant financial uncertainty and a nomadic existence, managed her volatile and frequently ailing husband, and yet somehow had both the time and inclination to participate in his career.

Late in 1850, perhaps early in 1851, Inness and his new wife departed on their first trip to Europe, which was paid for by Haggerty.[38] They sailed directly to Italy, where they stayed about fifteen months. The first part of the trip was spent in Florence, and its only noteworthy feature was that Inness's neighbor on the Via Sant' Apollonia was another American artist, William Page (1811–85).[39] When they became neighbors again, about fifteen years later, this time in America, Page exerted a considerable influence on Inness; but if there was any significant contact between them in 1850, nothing has been said of it.

Inness is next found in Rome, where he probably intended to spend a second year abroad. If so, his intentions were abruptly altered as the result of an incident reported in the London *Leader* and reprinted in the *New York Times* of July 9, 1852:

> In Rome, Mr. INNES [*sic.*], an American artist, refused—erroneously, we think —to lift his hat to the Pope, and was assaulted by a French officer, and imprisoned. The American minister, Mr. [Lewis] CASS, [Jr.], demanded his release, and was referred to the French authorities. Mr. CASS said he knew nothing of the French, but held the Roman authorities responsible. Mr. INNES was transferred from French to Roman custody, and released. Mr. CASS next challenged the French officer; but there could be no duel, because the French officer had already been placed under arrest.

The Innesses (including their daughter Elizabeth, born in Florence in 1850) were among the passengers listed in the *New York Times* of May 15, 1852, as arriving from Liverpool on the *S.S. Great Britain*. That Inness's address in the catalogue of the 1852 Academy exhibition (held in April) was still given as Italy indicates how precipitous and unexpected was his return.

The reversal in Inness's financial situation on his arrival in America is touchingly revealed in a series of letters from him to Samuel Gray Ward of Boston, who, he understood from Haggerty, had an order for a $100 picture that he desired to fill.[40] The first letter is dated June 7, about three weeks after his return: "I have just painted an American subject of the required price. . . . As $100.00 is at any time very desirable I take the liberty to write you this

and hope you will not purchase until you have seen what I have to show." On November 21, Inness wrote that the picture would be finished the following day: "As you expressed your self pleased when you last saw it I take the liberty of asking you for money[.] I should not do so but that three shillings is all I possess in the world and I know not where to get more. I dread asking Mr. Haggerty as I been [*sic*] almost entirely supported by him since I have been back from Europe." On November 30, he wrote to say that the picture would be sent the following day and to apologize for some unwarranted assumptions he had made in his previous letter:

> I pray you sir excuse an inadvertency, perhaps I should say an indelicacy[,] in the the letter I wrote you last Sunday week. Do not impute the *feeling* to me. I wrote in haste that I might be in time for the Mail and did not think of what I had omitted until the letter had gone. I am perfectly aware that I have never recd. an unqualified commission to paint the picture I send you and therefore look upon the matter as altogether a speculative one on my part. The frame that surrounds the picture is not suited to it, and I [illegible word] send it, having none better, that the picture may have all the advantages I can afford to give to it.

A major cause for the distressing condition these letters reveal was the suspension in 1851 of the activities of the American Art-Union while the legality of its method of distributing pictures by lottery was being decided—eventually not in its favor—in the courts. Almost from the beginning of his career, Inness's paintings had been purchased at good prices by the Art-Union, and so, in 1852, with the Art-Union gone,[41] reluctant to ask Haggerty for more money, and with a wife and two children to support (a second daughter, named after the artist Rosa Bonheur, had been born that year), Inness's financial predicament was serious.

By 1853, however, his situation had evidently improved considerably. Of the five pictures he exhibited at the Academy in 1853—in which year he was elected an associate member—three were lent by their owners. He was also able to make a second trip to Europe at the end of the year. This trip is usually assigned to 1854, but since the Innesses' third child, George Junior, was born in Paris on January 5, 1854, one may suppose that his birth was not coincident with the arrival of his parents in Paris. As we shall see, this second European trip caused a distinct alteration in Inness's style and inaugurated a new phase in his art.

The third and most influential stage of Inness's artistic education was the month he spent with Régis Gignoux in, as we have proposed, 1843. In older biographies of Inness, Gignoux is granted little if any significance (Royal

Cortissoz called him "a French mediocrity").[42] But this does him an injustice, for he was a well-respected artist and, as a pupil of Paul Delaroche, more soundly trained than most of his American colleagues—"perhaps the best-instructed landscape-painter in this country at that time," according to Montgomery Schulyer.[43] He also had a profound influence on Inness—not on his style, for there is little apparent similarity between Gignoux's delicately painted winter genre scenes in the seventeenth-century Dutch manner (*Ill. 2*) and Inness's paintings of the later 1840's (*Ills. 3–7 and Plate I*), but rather on his artistic orientation. Having received his training in France, Gignoux knew more thoroughly and admired more deeply the works of the old masters than did such Americans as Thomas Cole (1801–48) and Asher B. Durand (1796–1886), who studied them later in life and then without much enthusiasm.

If Inness was not unduly impressed by Gignoux's subject matter or style, he must have been touched by his enthusiasm and respect for earlier art, for in his own early works, Inness, too, sought his models among the old masters. It does not seem surprising that a young artist, particularly one whose training was as fragmented as Inness's was, should seek inspiration from the art of the past. But in America in the 1840's, it was neither fashionable nor obligatory to do so: his nearly exact contemporaries, the landscape painters Frederic Edwin Church (1825–1900), Sanford Robinson Gifford (1823–80), and Jasper Cropsey (1823–1900), found their exemplar not among the old masters but in the American artist Thomas Cole. Inness was indeed unique among contemporary American landscape painters, for he was not engaged, as they were, in the formulation of a distinctively native landscape art based on precedents established by Cole and Durand. Nevertheless, his early works are frequently compared to the landscapes of the Hudson River School.[44] It was, however, precisely his unwillingness to imitate the American landscape—the fundamental ambition of the Hudson River School—his emulation of old-master paintings, and his eagerness to perfect pictorial form rather than descriptive accuracy that was the principal source of critical displeasure. In 1847, a writer in *The Knickerbocker Magazine* said admiringly of Durand's paintings that "while we are looking at them, the illusion is such that we soon forget that they *are* paintings." [45] In Inness's case, this could not be forgotten. His art, then, did not develop away from an initial attachment to the Hudson River School but was from the beginning patterned on different sources and motivated by quite different concerns.

Although he knew and admired the Hudson River School artists, he looked beyond his own time and country for inspiration. And he did so, one may assume, largely with the encouragement of Gignoux. Inness's contemporary

critics unanimously noticed this orientation in his work, and just as unanim-
ously disapproved of it. The tone of this criticism is set by the earliest discussion
of Inness's paintings, in *The Literary World* in 1847. The critic conceded
Inness's "promise," but then said generally of his paintings at the Academy
that "they lack truth of color and composition," and of a particular painting
that "the clouds repeat the form of the trees, thereby destroying the idea of
space, and the trees are artificial."[46] Another critic wrote in a review of the
1848 Academy exhibition in the same publication: "We fear that he is be-
ginning to lose sight of Nature in the 'Old Masters.'"[47] The writer went so
far as to assert (wrongly) that Inness's paintings were imitations, even literal
copies, of works by Claude Lorrain. By 1849, this inclination to artificiality
was so well developed that a critic in *The Knickerbocker Magazine* could say
of one of Inness's Academy contributions:

> Mr. INNES [*sic*] is rapidly rising into excessive mannerism, and mannerism
> of the very worst kind. His fore-ground trees are the same color with his middle-
> distance hills, and over the whole picture a sad and heavy tone pervades, and
> wounds the eye. This young artist should study the *colors* of nature, and not so
> much the mere *form*.[48]

Inness's first trip to Europe changed nothing. He could be expected to seek
out the originals of works like those he had previously known only through
prints or copies, and a study of them would merely confirm the direction he
had been pursuing. Judging from the few surviving paintings of this period
(*Ill. 8*), this is indeed what happened. And when, in the course of his forced
return to America in 1852, Inness passed through Paris and attended the Salon
exhibition—where for the first time he encountered examples of the French
Barbizon School landscapes that would soon contribute to a conspicuous alter-
ation in his art—he was still so enamored of the deep, rich tones of old-master
paintings that he said a landscape by Théodore Rousseau "seemed . . . rather
metallic."[49] Nor did his critics detect any difference in his art after this Italian
trip. The *New York Tribune* said in its 1852 Academy review:

> Mr. INNES [*sic*], whose name is quite new upon the catalogue [which is,
> of course, untrue], exhibits several large-sized landscapes, which betray a much
> profounder regard for "old masters" than for Nature. They are not sincere pictures.
> He is consumed by the old landscapes. . . . Is an artist to-day to be satisfied with
> doing pictures which might be taken for Gasper [*sic*] Poussin's? Imitation when
> most perfect is then most hopeless. . . . The difficulty with Mr. INNES is, that
> he has gone all wrong, but there is no proof that he cannot go right if he will . . .

let him not be mastered by the Masters. The end of the artist in studying Raphael, Claude or Titian is not to know them, but Nature.[50]

In its Academy review a week later, *The Literary World* acknowledged Inness's "considerable natural talent" and his "evidently fine feeling for color," but having "allowed it to run away with" him, his

> pictures have become shallow affectations of that which is at best superficial to Art —the accomplishment, not the substance. What the condition of that mind can be which will resign not only all nature but even all that is most valuable in art, to a tone of color, we cannot conceive. The artist's mission is to interpret nature; what, then, is he who contents himself with studio concoctions as blank and wanting in the truths of nature as the canvas they are painted on? [51]

In 1853, *The Knickerbocker Magazine* praised Inness's Academy entries highly but, even so, remarked that "he seems to have sacrificed effect to his great love of mere *tone*. In this respect he will find that TIME, a greater toner than he, will entirely obliterate [his pictures]. They are too much like the 'old masters' for a 'young master.' " [52]

Many of the paintings discussed by his critics have disappeared, but in those that survive (*Ills. 3–8 and Plate I*) it is easy to see that their criticism was somewhat justified, for in compositional structure, motifs, tonality, and paint-handling, they do indeed recall the work of such old masters as Claude, Gaspard Poussin, or Meindert Hobbema. The latter was the only artist to whom Inness admitted an affinity, for when confronted many years later with one of his early paintings he said, "I remember that picture, I was thinking much of Hobbema when I painted it." [53]

What most disturbed Inness's critics was his stronger attraction to the compositional devices and tonal effects of the old masters than to the sincere and truthful imitation of natural appearances. To put it simply, he imitated art more than nature. He was captivated by "that which is at best superficial to art —the accomplishment, not the substance"; he was willing to "resign not only all nature, but even all that is most valuable in art, to a tone of color," to sacrifice "effects to his great love of mere *tone*," and to content himself with "studio concoctions." In other words, it was perfectly clear to Inness's critics, although they never said it in so many words and certainly did not like it, that he was deeply interested in artistic form, was more concerned with the language of art for its own sake than for its descriptive, imitative capacity. As a young artist anxious about the reception of his works, he must have been especially aware of the disapproval that they repeatedly provoked. That he was

not swayed by it indicates a steadfast devotion to practices that he found con-genial and fruitful, practices not designed, to the annoyance of his critics, to provide techniques for the faithful depiction of Nature, but rather to furnish the ability to produce a work of art, a "studio concoction" of primarily formal validity.

The later 1850's, beginning with Inness's second trip to Europe in 1853, was a pivotal period in his career, during which he struggled to master a new style and to support himself in the face of the diminished patronage and critical silence that greeted his reformed art. This is a period of enormous im-portance and interest, but it is also one about which we are the least informed.

Virtually nothing is known about Inness's crucial second trip abroad, except that it was spent in Paris. We are uncertain when he left, we do not know how or precisely what he studied, and we do not know exactly when he returned to America. He was represented in the 1855 Academy exhibition, and 1855 is usually the year given for his return; but both the *New York Times* and the *Tribune* of September 4, 1854, list a "G. Innis" as a passenger on the steamship *Pacific* from Liverpool.

The absence of critical attention during this period can only have been caused by disapproval of his paintings, for Inness was not unknown to critics, since he kept his studio in New York and exhibited regularly at the Academy. The critical silence was broken occasionally, but only to express disfavor. For instance, the critic of *The Knickerbocker Magazine* wrote as follows of Inness's "lamentable display" in the 1855 Academy exhibition:

> It is scarcely credible that an artist who is possessed of undoubted talents, and who has produced fine works, should so prostitute his ability as to paint like this. One of these pictures is a mass of green cheese dotted with sheep, (most persons imagine these sheep to be cows;) in the other, Mr. INNES [*sic*] has striven to give the effect immediately after a summer thunderstorm. He has made a con-glomeration of soft tallow and an astonishing rainbow. Mr. INNES, pray leave off such freaks, and paint as we know you *can* paint. Thus to trifle with yourself and the public is more than foolish: it is criminal.[54]

This and other comments like it are not unjustified, because Inness's paint-ings of this period are sometimes inept. But surely the critics were upset less by the deficiencies in his new style than by the style itself, which, though freed now from the conventions of old-master paintings, at the same time went too far in departing from the approved and established conventions of Ameri-can landscape painting. In 1860, a certain Mrs. Conant began with diffidence to describe a landscape by Inness that particularly moved her: "We almost

hesitate to express the strong impression it made upon us, lest, by awakening a false idea of its character, the first feeling on seeing it should be one of disappointment." For, she went on to imply, it was not at all like the works her readers were accustomed to: "It it not one of those striking picturesque works, where mountains, waterfalls, cliffs, and other romantic objects take the fancy by a *coup d'état,* and may cover up much that is poor or false in the rendering." [55]

No surviving paintings can be definitely assigned to Inness's French trip. Indeed, there are hardly any from the period 1853–55, suggesting that his efforts at this time were largely experimental and inconclusive—a characteristic, too, of much of his work in the half decade following this European visit. But if we are deprived of exact knowledge of the reformatory process that Inness's art underwent, there is no doubt that it was effective or that he had firmly committed himself to a new style. Nor is there any uncertainty about the source of this change, for the greater freedom of color and brushwork and the new informality of composition derive directly from French landscape painting of the Barbizon School, to which Inness had been fleetingly exposed in 1852, but which he evidently studied with great seriousness and to great effect on his return to France.

In a considerable number of paintings of the 1850's and 1860's, Inness closely imitated the subjects, mood, and style of Barbizon landscapes. One finds pastoral scenes (*Ills. 12, 14, 16, 18, 20, 29, 30*), country roads with sheep, cattle, and figures (*Ills. 23, 37, 38*), forest interiors (*Ills. 15, 31*), and single or clustered trees rising from a flat plain and silhouetted against a glowing sky (*Ills. 13, 19, 22, 26*). But such similarities in subject and style, while they establish both the existence and the extent of Inness's relationship to Barbizon landscapes, do not indicate precisely what this relationship was. For although the change brought about by Barbizon influence was considerable and conspicuous, it was not revolutionary; it involved not the complete expulsion of one stylistic vocabulary in favor of another but rather the liberation and augmentation of elements of form and content that already existed in his art. The Barbizon style, then, acted less as a sudden revelation than as a catalytic agent that freed and made visible qualities already latent in Inness's art and imagination. If some of his paintings are so much like Barbizon landscapes as to suggest that he was little more than an imitator of them, in as many others he seems more intent upon extracting certain principles of style that are then used to reshape and refine pre-existing elements of his art.

For example, in several paintings done shortly after his return from France (*Ills. 12, 13, 15, 16*), one finds the same three features: a free handling of paint

not conforming to the shape of any particular object but suggesting rather its substance, texture, and enclosing atmosphere; brighter, less tonally harmonious colors; and distinctly rectilinear construction. All may be found to varying degrees in Barbizon art. But in Inness's work they are more obtrusive, because he was using them to reform related properties of his previous style: free brushwork (on occasion poorly controlled) replaces the tighter, meticulous handling of his earlier work; brighter color replaces "tone"; and rectilinear construction replaces the sinuous forms, especially of trees, that Inness borrowed from Baroque landscapes. In each painting, he modified an element of his art according to the example of Barbizon landscapes, but he did not add new elements or pictorial ideas—did not suddenly become aware of color, composition, or broad handling that he had been totally innocent of earlier.

A number of paintings done at this time indicate that Inness was reluctant to abandon entirely features of his earlier art and that he tried instead to effect a compromise between it and Barbizon art or, more generally still, to work out an accommodation between French and American approaches to the genre of landscape. For example, *The Juniata River near Harrisburg, Pennsylvania* of 1856 (*Ill. 14*), with its open, sunny, atmospheric treatment of a commonplace subject clearly derived from Barbizon paintings, seems at first entirely unrelated to his earlier (1850), highly conventional painting of *March of the Crusaders* (*Ill. 7*); yet the differences are more superficial than essential, since the arrangement of the framing trees and winding river is virtually identical in the two pictures. *The Lackawanna Valley*, of 1855 (*Ill. 11*), his best-known painting of this period, has a freshness of light, an informality of subject and arrangement, and a breadth of handling, all of which stem from Barbizon landscapes. But its conspicuously panoramic scope is not so derived. As in *The Juniata River near Harrisburg, Pennsylvania*, in which some properties of Barbizon style were in effect laid over a conventional compositional pattern, so in *The Lackawanna Valley* Inness has applied the informality and intimacy of Barbizon landscapes to a vast panoramic vision that is characteristic of the American Hudson River School.[56]

Because Inness would not or could not assume the easy role of being a mere imitator of Barbizon style but sought to understand its essence and graft it upon or blend it with his earlier art, his task was not a simple one. This goes far in accounting for the hesitant and experimental quality of much of his work of the later 1850's—it explains, too, some of the critical complaints about it. His *St. Peter's, Rome* of 1857 (*Ill. 17*) is splendidly light and atmospheric in the distance, but the foreground is both fussy and fuzzy, indicating a tentative command of Barbizon style. This uncertainty also shows up in works that

are more purely in the Barbizon idiom. *Near the Lake* (*Ill. 12*), probably of 1856, is hardly more than a sketch, but for this very reason, it provides a good example of Inness's ineptitude at this time.[57] There are, in number and kind, many more brushstrokes than necessary to the effect, and they fail to give to the objects they depict a persuasive illusion of substance or texture. More finished paintings, such as *Autumn* of 1856–60 (*Ill. 16*), and *Midsummer Greens,* of 1856 (*Ill. 15*), display the same features, but with less obviousness. Even the later *Hackensack Meadows, Sunset* of 1859 (*Ill. 19*), with passages of strikingly subtle color and, in general, a marked improvement over the paintings just described, is still in places somewhat weak. For example, in the largest cluster of trees, the brushwork gives an indecisive impression of leaves with light playing upon them and does not reveal the structure of the trees. The result is an unconvincing and unpleasant cottony effect.

Inness's Barbizon-inspired works are not consistently reminiscent of a single Barbizon artist—no more so than his earlier works recalled a single old master. And yet, many paintings of the 1850's and 1860's do suggest that the painter who was most influential was Théodore Rousseau (1812–67), to whose painting Inness was attracted in the 1852 Salon. The effect of light and shadow in *The Juniata River near Harrisburg, Pennsylvania* or *Clearing Up,* and enframing trees of *Near the Lake* have an evident source in Rousseau (compare *Plate II and Ill. 9*). There are often hints of Jules Dupré (1811–89), Narcisse Diaz de La Peña (1807–76), and Jean Baptiste Camille Corot (1796–1875), but Rousseau's influence is the strongest and most enduring in Inness's landscapes of the later 1850's and the 1860's, as was often noted. A sympathetic correspondent to the *Boston Transcript* of February 19, 1862, wrote that Rousseau was Inness's "great light, his guiding star," and Henry Tuckerman wrote in 1867, although with some exaggeration, that Inness "is an admirer of Rousseau, and reproduces his manner perfectly." [58] Inness himself claimed that "Rousseau was perhaps the greatest French landscape painter." [59]

Inness was not, however, a mindless and repetitive copier of Rousseau or of any other artist. One's ultimate feeling is that his emulation of Rousseau and the Barbizon School, like his earlier emulation of the old masters, was not the result of a deficient will or imagination as much as an attempt to penetrate to the heart of an admired style, not merely to master its apparent traits but somehow to participate in its generative impulses and, most of all, to extract from it an artistic vehicle displaying his own individuality.

The year 1860 marks the beginning of a new period in Inness's life and art. In that year he left New York to live in the village of Medfield, Massachusetts,

and at about that time, too, changes of several kinds became apparent in his art. The year commonly given for Inness's departure is 1859,[60] but this is incorrect: his address in the 1860 Academy catalogue was listed as Brooklyn, in a studio he had taken just a short time before.[61] Only on June 16 was it announced in the *New York Tribune* that he had left New York: "George Inness has taken up his easel and left New York, to plant himself in one of the pleasant villages in the vicinity of Boston, where he intends to reside permanently." Somewhat more interesting is why he left New York. Inness had clearly suffered in the later 1850's from the neglect of patrons and critics and may have sought a more favorable climate in Boston, but the most likely reason for his departure was his poor health. That he was, in fact, perilously ill in 1860 is indicated by Mrs. Conant, writing in *The Independent* on December 27, in praise of a recent picture by Inness:

> . . . our admiration for him has been constantly growing, and we do not fear to prognosticate for him—should he live a few years longer—no second place among American landscapists. Should he live! We write the words sadly; for alas! in this, as in so many other cases, the flame of genius burns in too slight a temple. A feeble frame, of the most sensitive nervous organization, compelled to intense and protracted labor by the fiery energy within, cannot be expected to hold out long. We trust that in saying this we do not sin against the sacred privacy of personal history.

This not only testifies to Inness's illness, for which he sought relief and cure through rural life, but provides the earliest and one of the most vivid, if somewhat romantic, accounts of his intense, nervous personality.

About 1860, as we have mentioned, Inness emerged rather suddenly from obscurity and displayed a new maturity in his art. *Clearing Up (Plate II)* indicates that he had lost most of his hesitancy and was able to produce a work of conviction and authority—and considerable beauty. His works of the 1860's are, on occasion, still a bit ponderous and finicky, but they are not as tentative as those of the 1850's, and on the whole it can be said that Inness was now at ease with and in control of his style. His new sense of authority is reflected in critical acclaim: the *Tribune* described him as "a man of unquestionable genius" and "one of the finest and most poetical interpreters of Nature in her quiet moods. . . ." [62] *The Crayon* spoke of the "mastery" of color and execution in his Academy pictures,[63] and the critic of the *Courier des États-Unis* was quoted in the *New York Evening Post* as having said: "I do not know what popularity has been so long held back to consecrate a talent so remarkable." [64]

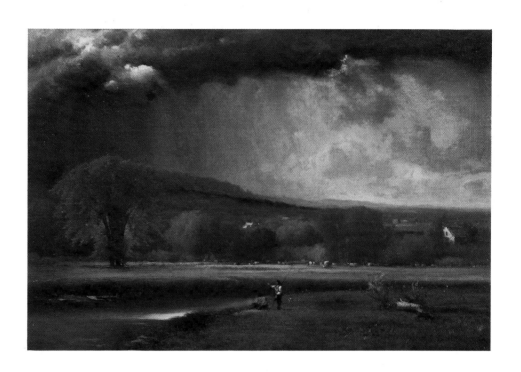

PLATE IV. *Approaching Storm*. 1868. Oil on canvas, 16 x 24 inches.
Formerly George F. McMurray Collection, Burbank, California.

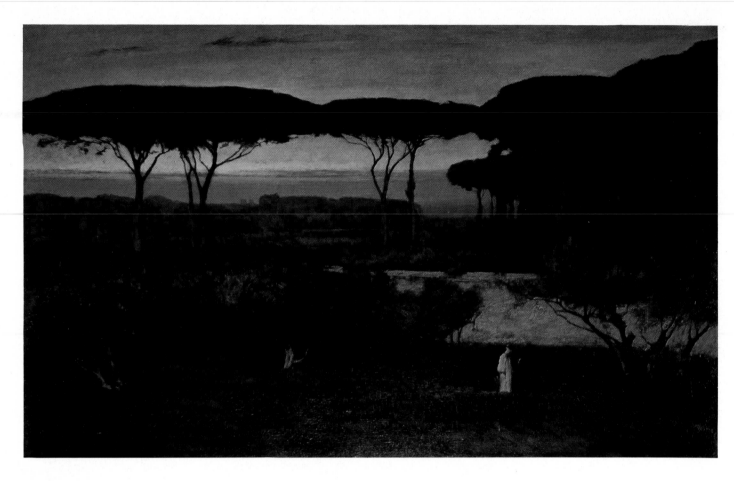

PLATE V. *The Monk*. 1873. Oil on canvas, 38½ x 64½ inches.
Addison Gallery of American Art, Phillips Academy, Andover, Massachusetts.

Inness's rise from obscurity, however, was due not simply to artistic improvement but also to the efforts of George Ward Nichols (1831–85), who acted as his agent. Little is known about him. He apparently studied art in Paris in the late 1850's, served as art critic for the *New York Evening Post* in the early 1860's, was proprietor of the Crayon Art Gallery, served in the Union Army, and, in 1868, settled in Cincinnati, where his activities centered mainly around music.

Nichols was only the first of several agents to whom Inness entrusted the sale of his works, but the restoration of his reputation was fundamentally of his own doing, for in Boston, away from New York and from Nichols (who was then in the army), his work was highly praised, and for the first time in his career he attracted both followers and a pupil, Mark Fisher, who later studied in France and settled after 1872 in England, where he had a modest success as a painter of Impressionist landscapes.

Although Inness attracted students throughout his career, he exerted little influence on them. They were either unimportant artists or else, as in the case of Louis Comfort Tiffany, found success in ways quite different from Inness's. Inness did have considerable influence on Alexander Wyant (1836–92), Homer Martin (1836–97), Dwight W. Tryon (1849–1925), Elliott Daingerfield (1859–1932), and J. Francis Murphy (1853–1921), but primarily through the example of his works. He was too engrossed in his own painting problems to give students proper attention or lucid explanations (evidently his favorite method of instruction was simply to repaint the student's picture).

Inness was deeply stirred by the Civil War; he was, Schuyler says, "never more excited than when the news of the firing upon Sumter reached the village [Medfield], for he was not only a fervent American but an Abolitionist from his youth up." [65] He tried to enlist, but was prevented by poor health. However, he participated in other ways. The *New York Evening Post* reported on August 19, 1862:

> George Inness has done the next thing to going, the quota of ten men for the town of Medfield, where he resides, not appearing, he called a meeting, rushed into town, obtained one hundred dollars, rushed back again to his studio, used up ten dollars' worth of cobalts, cadmiums and lakes in painting a placard, "Come to the meeting," "Rally," etc.; went to the meeting in time to make an eloquent speech, gave his one hundred dollars to the first man who put down his name; he then pitched into a lot of rich old fellows on the platform, because they did not offer bounties, whereupon they came down with the funds, and the quota was filled.

In addition to this practical act of patriotism, Inness expressed his love of country in a major painting called *The Sign of Promise,* executed in 1862 and exhibited to much acclaim the following year. Although it no longer exists, its appearance and meaning are revealed in a contemporary description: it was "a comingling of vaporous clouds and azure sky, murmuring stream and quiet meadow, field and forest, hills and mountains, and over all the rainbow of hope, following the storm, gives glorious promise of peace and joy to come." [66] Inness repainted it into *Peace and Plenty (Ill. 30)* in 1865.[67]

Late in 1863 or early in 1864, Inness left Medfield to settle in Eagleswood, an estate near Perth Amboy, New Jersey, which had an interesting history, for at one time it housed one of those communal, utopian, religious societies then in vogue, known formally as the Raritan Bay Union.[68] By the time the Innesses arrived in Eagleswood the Raritan Bay Union had been dissolved, but Marcus Spring, its guiding spirit, continued to live there, and something of its idealistic, radical flavor survived into the 1860's.

We know that Inness was a religious man and possibly an abolitionist; his later interest in the theories of Henry George indicates his sensitivity to social problems. Therefore, his concerns would seem to coincide with those that flourished at Eagleswood, thereby making it a most congenial place for him to live.

Even more attractive was the presence there of other artists, the most prominent being William Page. It may be entirely coincidental, but the fact that, at this time, two major artists (Inness and Page), as well as several minor ones and some pupils,[69] were residing in a place that not too many years before had housed a communal society suggests that it may have been Spring's desire to revive its communal character, but now with an artistic rather than socialistic orientation.

Of one thing, at least, we can be certain: Inness knew and was deeply impressed by William Page, his neighbor at Eagleswood. While they apparently quarreled and parted on unfriendly terms, it was clear to some contemporary critics that Inness's art showed Page's influence at this time.[70] But Inness's most abiding debt to Page was that, through him, he became a devoted and acknowledged follower of the teachings of the Swedish scientist-mystic Emanuel Swedenborg—finding, at last, a religious doctrine that satisfied him.

Inness did not travel abroad during the 1860's, and did not seek or encounter any new stylistic influences. Nor does any clear change in style, such as occurred in 1854, separate his art of the 1860's from that of the half decade pre-

ceding it. Nevertheless, the 1860's represent a new and distinct phase in his development.

Before 1860, Inness's primary, if not exclusive, objective was the mastery of artistic form—learning and applying the lessons of the old masters and then those of the Barbizon painters. In the 1860's, the emphasis shifted from form to content, as he explored and enhanced the meaningfulness of his art. This may stem from or be another indication of the formal and technical assurance that he had developed by the 1860's. But, while surely in large part self-generated, his greater interest in pictorial content may well have been fortified by an impressive personality with whom he was in contact during this decade: the Reverend Henry Ward Beecher (1813–89). Pastor of Plymouth Church in Brooklyn and one of the most esteemed public figures of the period, Beecher was also one of Nichols's customers and perhaps in this way came into contact with Inness and his art. By 1860, at any rate, Beecher owned at least one of Inness's paintings,[71] and upon his death in 1887, had five in his collection—more than by any other painter. He believed Inness to be "the first of American painters."[72] The only certain evidence of a Beecher-Inness acquaintanceship dates from the 1870's, but it would be exceedingly improbable if they had not met earlier, particularly at the time when Beecher was most actively engaged in acquiring Inness's work, that is, in the early 1860's.

Beecher, who had a deep and genuine love of nature, often suggested that in nature one may discover signs of divine immanence and transcendent meaning. "He who paints or describes with the senses alone is but a surface artist," he wrote in 1857. "This superficial reading of Nature is as if one had been taught, like Milton's daughters, to read the Greek language fluently without understanding any part of its meaning. The sound is sweet, the reading fluent. But all the life and contents are wanting. And he that reads Nature reads God's language." But if one adds reason, imagination, and religious feeling to a mere sensory reading of Nature, then "the heavens declare the *glory of God,* and the firmament showeth his handiwork. Then day unto day uttereth speech, night unto night showeth knowledge." "One man communes with natural objects by many more faculties than another," he went on, and such a man constitutes the true artist. "One artist represents Nature seen with the *eyes* simply; another, as seen with the *soul.* And though we cannot by form or color represent all or the chief part of that which the mind perceives, yet what we do picture will be very different if seen only superficially or likewise with feeling."[73]

He wrote elsewhere, "We regard Art, in its higher offices, as a LANGUAGE. And as a poet, an orator, or a writer employs words or sentences to convey thoughts and feelings, so the artist employs forms, colors and symmetries to convey some sentiment or truth." [74] Or, still elsewhere:

> Artist is Interpreter. He teaches man by opening through imitation the message of deeds, events, or objects, so that they rise from the senses, where before they had exclusively presented themselves, and speak to the higher feelings. A man who sees in Nature nothing but materiality, is no more an artist than he is a musician who, in one of Beethoven's symphonies, hears only noise.[75]

Beecher's interest in art, from the standpoint of a collector and, in a crude way, a theoretician, is clear. The critical question, however, is whether Beecher had any influence on the character of Inness's art. We do know that Beecher expressed his opinions to artists in whom he was interested,[76] and that Inness satisfied Beecher's artistic criteria, for in 1870, Beecher pronounced him "the best American painter of Nature in her moods of real human feeling." [77] And it seems also that both the time and nature of the change (or change of emphasis) in Inness's art can be attributed to the influential presence of Henry Ward Beecher.

The alteration that took place was not, as we have said, stylistic. But if one compares the titles of Inness's earlier works with those of the 1860's, the nature of the change becomes apparent. Before 1854, the paintings that were not called simply landscapes or views of a particular place bore such titles as *Lament* or *Peace and War*; such works had a narrative content, usually carried by accessory figures rather than by the landscape itself. After Inness's second European trip, literary or allegorical subjects disappeared from his art; his titles referred now to specific locales, and in this, one again sees the influence of the Barbizon painters, who, for the most part, also eliminated explicitly allegorical subjects from their landscapes.

In 1862, one of the three paintings that Inness exhibited at the Academy bore the title *The Light Triumphant* (*Ill. 22*), which had been given it by Henry Ward Beecher.[78] No comparable title can be found in Inness's earlier work, and it is significant not only because it indicates a revived interest in expressive content, but because it suggests that the theme resided in the landscape itself— and in light particularly—rather than in accessory figures. The painting differs from Inness's previous work in being spiritualized, its glowing light intensified by emerging from behind a large tree and becoming an almost mystical radiance about it. It is not a commonplace natural effect, but an exaggerated one, pregnant with meaning.

It might be argued that the allegorical content Beecher saw in this picture originally had nothing to do with Inness's purpose in painting it. By August of 1862, however, Inness was reported "at work on a large allegorical landscape, which *he calls* [author's italics] the 'Sign of Hope.' " [79] To this picture, such a hypothesis clearly cannot apply, for it was intended from the beginning as an allegorical painting—one, furthermore, whose meaning and title were supplied by the artist himself. When it was exhibited the following year as *The Sign of Promise* at Snedecor's Gallery in New York, it was accompanied by a pamphlet, awkward enough to have been written by Inness himself, in which was stated:

> He does not offer this picture as a perfect illustration of the epic in landscape, but only as the visible expression of a strongly felt emotion of Hope and Promise. . . . The feeling sought to be conveyed, the true meaning of the picture will not be found in any hieroglyphics, for which those who seek them will seek in vain. If the picture presents not to the observer more than he sees, the picture is clearly a failure—at least to him.[80]

Inness's allegorical intentions in this painting were not lost on his critics: "Inness' picture contains that subtle essence which merges the spiritual and the material," said one.[81] James Jackson Jarves remarked: "His picture illustrates phases of mind and feelings. He uses nature's forms simply as a landscape to express thought." [82] And a letter in the *New York Evening Post* read: ". . . the picture has a moral in its subject and a moral in its treatment. It expresses hopefulness, the promise of good; it implies a divine purpose in the fertilizing shower, the genial sunshine, the beautiful and fruitful valley, and in the continuation of these in a grand union surely not unmeaning." [83] As Inness implied, and as his critics easily understood, the painting represented a natural allegory of the Civil War—the promise of hope and goodness seen even through the storm of war, with divine providence omnipresent. It is interesting to note how like Henry Ward Beecher's writings the statements by Inness and his critics were; the point is not that Beecher influenced critics like Jarves (as he may well have influenced Inness), but that Inness's landscapes could now be described and his artistic aims interpreted—indeed, commonly were—in terms consonant with Beecher's views.

Peace and Plenty, a work of 1865 (*Ill. 30*), was painted over *The Sign of Promise*. It is, as the title indicates, a pleasant harvest scene, not unlike *The Light Triumphant*. It, too, is an allegorical landscape, celebrating the "peace and plenty" that replaced the strife of war. The meaning of this new theme is enhanced by the fact that it was painted over the other scene and therefore

became quite literally the fulfillment of the hope and promise that were the theme of the earlier painting.

In 1873, commenting in the *Atlantic Monthly* on some paintings by Inness then on exhibition in Boston, the writer and critic George P. Lathrop expressed his belief that Inness's work of the previous decade had a distinct character. Having described a sunset landscape, he went on to say of it and other paintings of this time:

> This picture gives the whole chord of which the painter was continually sounding the key-note at this period. It is easy to see that this strong, poetic genius is tyrannized over by his moods. So long as golden sunsets melting into darksome nights moved him the most strongly, he would paint little else. Whether it was after this time that Inness produced his great picture of a rainbow, "The Sign of Promise," we do not at this moment recall. We are inclined, however, to believe that it was. At least it would have been a fitting solution to the vague problem which his brush is here ever striving to express.[84]

The interest of Lathrop's remarks lies in his suggestion that *The Sign of Promise* and other overtly allegorical landscapes are but the more conspicuous instances of a general symbolic tendency in Inness's art of this period. In few paintings is the meaning as clear and specific as in *The Light Triumphant, The Sign of Promise,* or *Peace and Plenty.* But in all of the paintings of the 1860's, nature is not merely depicted straightforwardly, but is made articulate: moods of calm are emphatically peaceful (*Ills. 25, 27, 30, 40, 41, 42*), rainbows are clearly portentous (*Ills. 20, 21*), storms are dramatic and threatening (*Ills. 29, 34, and Plate IV*), sunsets are gloriously radiant (*Ills. 24, 26, 28, and Plate III*), and bleakness is unmistakably harsh and cold (*Ills. 32, 33*). In 1865, a writer remarked that Inness "signally [possessed the power of] seizing upon the critical moment in some marked phase of nature."[85] The result is that one is made aware of the spiritual significance of nature through the way in which its visible forms and effects reflect some higher power.

The period from 1870 to 1884 was one of unusual activity for Inness. It began with a four-year trip to Europe, which was followed by two years in Boston, and two in New York. The remaining years of his life were spent in Montclair, New Jersey. Inness's art was no less active, for in contrast to earlier periods in which a single style or idea predominated, he now investigated, sometimes almost simultaneously, a number of theoretical and stylistic problems. It was less a time for learning than for searching and questioning, a

period from which some of his most beautiful paintings date, yet also a period of gestation, out of which still greater works would come.

Inness's third trip to Europe began in April, 1870,[86] and by mid-summer he was settled in Rome, where—except for summer excursions to Tivoli, Albano, Venice, and Pieve di Cadore (Titian's birthplace)—he would stay until the spring of 1874, when he moved to Paris so that his son could study art (George Junior was briefly a pupil of Léon Bonnat). This third European trip was made not for purposes of study but as a business venture in collaboration with his dealers, Williams & Everett of Boston, who received all of his European paintings, with the exception of those he sold in Europe, apparently in return for regular payments. Late in 1874, a correspondent to *Appleton's Journal* reported that Inness planned to stay in Europe "indefinitely," [87] but he returned to Boston early the following year. The reason for his sudden change in plans was that Williams & Everett could no longer afford to support him, and so, with his works not selling well in Europe either,[88] Inness hurried home to make a new arrangement with another firm of Boston picture dealers, Doll & Richards.[89]

In the early summer of 1875, Inness departed for the White Mountains of New Hampshire, which at this time were an equal if not a greater attraction than the Catskills for vacationers and artists. Their popularity may explain Inness's presence there—continuing in America the practice he followed in Europe of painting popular scenic subjects. He did more than paint pictures at this time, for the *Boston Transcript* reported on September 7 that "the elder Inness is still at North Conway. He is understood to be engaged in writing a work of some kind upon art." The work itself has not survived, but the mere fact that he was writing is significant, for it indicates the beginning of a period of serious theoretical concern on Inness's part. This did not arise suddenly at this time, but had been developing throughout the 1860's, strengthened by contacts with Beecher and William Page ("a tyrannical and consistent theorist") [90] and, through the latter, with the teachings of Swedenborg.

Inness fled Boston in 1876 in order to extract himself from the agreement he had made the year before with Doll & Richards, the terms of which, in brief, were as follows: they advanced him about $5,000, repayable on demand, for which they received a certain number of paintings, to remain their property as security, as well as the right to be Inness's exclusive selling agents.[91] The agreement was no doubt a strict one, but times were hard, for the depression of 1873 had followed immediately on the heels of the disastrous Boston fire of 1872 (circumstances, surely, that had forced Williams & Everett to halt their ar-

rangement with Inness). However, it was a perfectly legal arrangement—which is more than can be said for Inness's actions to escape it. In 1876, Doll & Richards evidently demanded repayment of the money they advanced to Inness. He in turn approached his former dealers, Williams & Everett, who gave him money in exchange for pictures—a completely illegal and unethical move, since he was still under contract to Doll & Richards. Using the money so obtained, he quietly left Boston for New York, bearing with him one of the pictures owned by Doll & Richards by the terms of their agreement, the large *Pine Grove of the Villa Barberini, Albano* (*Ill. 60*). In order to recover some of the money they had advanced to Inness, Doll & Richards sold the paintings by him in their possession and also brought suit against him to recover the rest. Inness countered by charging them with "wrongful conversion" in selling his works, claiming they did not in fact own them.[92] But this claim had no substance, and he was later compelled to acknowledge legally Doll & Richards's rightful ownership of his paintings.

Inness stayed in New York after his clandestine departure from Boston. In 1878, he took a studio in the old New York University Building, which housed a number of prominent artists.[93] In this year also, two events occurred that insured Inness a large measure of the domestic stability and financial security that had thus far eluded him: he acquired the house and property in Montclair, New Jersey, where he would live for the remainder of his life, and he took as his agent Thomas B. Clarke (1848–1931), who at this time also became Inness's lifelong patron and devoted friend.

Though it was announced in 1875 that Inness was writing a work on art, it is not until 1878 that we have any actual examples of his literary and intellectual activity. In this year, he accompanied his work at the Academy with some poetry of his own composition: "Under his green and yellow landscapes he now affixes a tablet bearing strange words, more or less rhythmical, more or less reasonable. These are the lucubrations of Mr. Inness' own brain; he disdains the trumpery poets of acknowledged literature and supplies his own legends from his own muse."[94]

If Inness's poetry was not much appreciated, his views on art—which appeared in *Harper's New Monthly Magazine*, in 1878, as "A Painter on Painting"—were very favorably received. And on June 3, 1879, he appeared in print again, in an interview for the *New York Evening Post* entitled "Strong Talk on Art." This was principally a criticism of the National Academy of Design, an institution under strong fire at this time from the young artists who had founded the Society of American Artists in 1877, as well as from its allies among the older generation, including Inness. Inness's fundamental objection

to the Academy—although it must be said that he was associated with it for his entire professional life, and his body lay there in state at his death—was that it was not democratic:

> . . . it is about impossible for genius or even brilliant talents to enter its building unless favored by conditions, either moral or social, with which art has nothing to do. The most mediocre artistic ability on the part of a candidate for admission, if accompanied by the writ to keep his nose clean and his shoes well brushed, or still better, by business, social or political talents, with enough money for a "spread" once in a while, are of more weight than any show of true artistic instincts.

Inness was not alone in expressing dissatisfaction with the Academy or in seeking alternatives to it; the Society of American Artists did both. Yet, whereas the members of the Society were annoyed at the poor reception and display of their paintings by the Academy, Inness's annoyance was more emotional than professional. Indeed, it was not mere annoyance that he expressed but accumulated frustration, resentment, and hurt, for despite his steady representation in its exhibitions and the great (if belated) honor it would pay him after his death, Inness was not well treated by the Academy. He was not made a full Academician until 1868, long after such contemporaries as Church, Gifford, and Cropsey were so honored. This resulted from the Academy's disapproval of his style, to be sure, but one gathers from his remarks that he felt a personal exclusion as well, since he was certainly describing his own situation when he said it was not artistic merit that gained one's admission to the Academy and to its higher councils but business ability, social graces and connections, and even appearance—in all of which Inness was notoriously deficient. He willingly placed his business affairs in other hands. Jasper Cropsey found him "something of a (delicately called) 'boor,' " [95] and a later writer publicly mentioned his "ignorance of the 'savoir-faire' of life." [96] His clothing and grooming, as both anecdotes and photographs attest, were not matters of deep concern to him. He must have felt excluded on such grounds for a long time, but it was especially upsetting at this period, when, widely celebrated as one of America's most important artists,[97] he still had no commensurately important role in its most powerful artistic organization.

In addition to the *New York Evening Post* interview, Inness expressed himself again in 1879 in *The Art Journal,* in an interview entitled "Mr. Inness on Art-Matters." This rather sudden attentiveness to Inness's ideas and opinions in 1878 and 1879 is a clear sign of the respect his art commanded at this time. Admiration even extended across the Atlantic, for in 1879, his *St. Peter's, Rome,*

exhibited at the 1878 Paris Exposition, was favorably mentioned by the English critic and biographer of Turner, Philip Gilbert Hamerton.[98]

Inness's reputation grew still greater in the 1880's. In 1882, there appeared the most interesting and important article on him published during his lifetime. It was written by the American critic Charles De Kay, using the pen name of "Henry Eckford," and it appeared in *The Century*.[99] It differs from other contemporary discussions of Inness in being less biographical than critical. De Kay is clearly partisan; he does not, however, expend his energies defending or justifying but rather in explaining Inness's art in terms of the ideas that shaped it and its historical development. Indeed, he was the first to look at Inness's works in this way and to attempt to discover in them some pattern of growth, indicating that his style had attained the condition of maturity that permits such treatment.

In 1884, there was a large exhibition of Inness's works, which even more clearly displayed his stature. It was organized by James F. Sutton, proprietor of the American Art Association. It included fifty-seven paintings, from 1857 to that year, accompanied by an impressive catalogue with an introduction by the critic Ripley Hitchcock, for which Inness supplied information in a long letter that is the most important single surviving autobiographical document. It also contained some critical comments from the press, along with excerpts from the 1878 "A Painter on Painting" and from De Kay's article. Together, the exhibition and catalogue provided the most comprehensive review of Inness's art to date: a selection of paintings covering almost thirty years, an up-to-date and reliable biography, critical appraisals, and some of Inness's own writings. The exhibition was not a financial success, but it did attract large crowds and may have been responsible, as Sutton believed,[100] for elevating Inness to the position of lofty prominence he occupied during the last decade of his life.

The period from 1870 to 1884 was the richest in Inness's art, not so much in terms of the quality of work produced, though this is high, but in the variety of theoretical and formal ideas he explored. Because it began with the four-year trip abroad, one might suppose that this explains the artist's succeeding activity, but in fact, as has been noted, Inness went abroad neither to study nor for a reinvigorating exposure to art, but to paint saleable pictures for his dealers. His wife recalled that he spent most of the time working,[101] and if he did look at other pictures, his visits to Titian's birthplace and his reputed inhabitancy of Claude's studio in Rome suggest that the old masters intrigued him more than modern ones. Furthermore, Italy was, regardless of its scenic beauties, considerably less advanced artistically than France at the time. And

when Inness did go to France, it was in order to benefit his son's career and to paint some different scenery. In sum, he went abroad primarily for practical reasons, not to reform his art. There is no reason, therefore, to expect any changes to have occurred in his style, yet they occurred nevertheless.

Inness's earliest Italian paintings were, as his friend the Boston artist and critic Darius Cobb said, departures "from the breadth of his earlier manner to an undue attention to detail and ornateness." [102] Meticulous realism is certainly a feature of many of his Italian paintings (*Ills. 39, 43, 46*), and it surely stemmed from his desire—or obligation—to develop a popular style as the proper accompaniment to the popular, picturesque subjects he was portraying ("finish is what the picture-dealers cry for," he said a few years later). [103] This heightened realism, however, is not a consistent part of Inness's European work, nor does it survive his return to America. Indeed, the first Italian paintings that Inness showed at the Academy, in 1874, suffered in critical judgment not from excessive precision but, on the contrary, from excessive breadth. Of *Washing Day, Near Perugia, Italy*, a writer in the *New York Evening Post* said: "Clouds, figures, trees and architecture are mere blotches of paint, just sufficiently shaped to convey an idea of relative position." [104] The critic Clarence Cook dismissed the painting with brevity and wit: "Mr. Inness does not look much like himself in 'Washing Day in Perugia,' and we are sure it doesn't look much like Perugia, or like any other place that can be named." [105] And in the following year, the critic of the *New York Times* said of a *Scene at Perugia* at the Academy: "Mr. Inness' work is always suggestive, but there is frequently, as in this composition, a carelessness in the matter of detail which strikes the spectator disagreeably." [106] There is no easy way to account for this tendency, since nothing in his Italian environment, either among native works or those of foreigners in Italy, seems to have influenced it. Inness's art was "always suggestive," as one critic said; during the early 1870's it simply became more so (*Ills. 44, 45, 48, 50, 52, 53, 55, and Plate VI*).

Color had always been the most prominent formal and expressive element in Inness's art; in 1852, a critic asked in bafflement how he could "resign not only all nature but even all that is most valuable in art, to a tone of color." But, beginning in the later 1870's it assumed still greater importance. In 1878, this was indicated simply by the titles of the paintings he sent to the Academy: *The After Glow, The Morning Sun,* and *The Rainbow.* In reviews of the exhibition, Inness was described as "essentially a colorist, a luminarist," [107] and "one of the few painters we have who can be called colorists." [108] However, these same critics were not entirely satisfied with Inness's use of color: the former felt he sacrificed form and structure to color; the latter said his colors

lacked "self-restraint" and that his paintings had acquired "a new touch of what looks like bumptiousness. They are violent instead of dignified, loud instead of deep in color. They would be improved by hanging in a smokey chimney." Clarence Cook wrote that his "pictures are so noisy this year, that it takes a quiet hour to listen to them." [109]

These remarks are not without interesting implications. Simply to point out Inness's attraction to color does not contribute a new or valuable critical insight. But now his colors had become, in the estimation of his critics, so discordant that toning by smoke was recommended. Inness himself made some comments indicating that his critics were not unjustified in their evaluations—if unreasonable in the way they phrased them. A small controversy developed in the spring of 1878 over a suggestion by the painter John La Farge (1835–1910) that wood-engravers be included among artists representing the United States at the upcoming Paris Exposition. On March 21, Inness wrote a letter to the *New York Evening Post* in which he disputed on several grounds the equality of wood-engravers and painters: the painter produces original work, the engraver only imitates; the painter, because he works from nature, must have greater resources than the engraver, who only reproduces; and, finally,

> . . . the painter must be a colorist—the most difficult thing in the world. Where are our colorists? Every painter tries to be one, but how many of us succeed? No artist feels that he perfectly succeeds with his color—with that which is the soul of his painting. The demands made upon a painter in this direction are so great that sometimes he feels that almost anybody can do work in black and white, but that nobody can adequately reproduce the harmonies of nature in color.

Inness's defense of painting against wood-engraving accounts for some of the stress he placed upon color, but his remarks must also reflect his more respectful appreciation of the difficulties it posed, and suggests he had somehow acquired a more sophisticated understanding of both its potentials and problems. And in experimenting now with color rather than tonal values, he offended critics unaccustomed to such adventuresome chromatic investigation.

Inness was in Paris in the spring of 1874, in time to see or to experience the excitement generated by the first exhibition of the French Impressionists. But whether he saw their works then or discovered them later (his first mention of them is in 1879), he was not entranced with them. Impressionism, he believed, shared with English Pre-Raphaelitism the false assumption that "the material is the real." [110] He described Impressionism later as "a mere passing fad" and a "sham." [111] These sentiments, however, seem to be contradicted by the appearance of his later paintings, for their allusiveness and refined color recall particu-

larly Monet's paintings of the 1880's and after. Indeed, Inness's later canvases (*Ill. 86*) were (and still are) frequently described as Impressionist, though in fact they were conceived in quite a different spirit and have a different effect. They do not record the transient qualities of nature nor do they investigate with scientific impartiality either objective reality or the laws of color used in registering it; rather, they depict a different order of reality, and are at once more purely aesthetic and more meaningful than French Impressionist paintings commonly are.

Regardless of Inness's misgivings about Impressionism—whether genuine or an attempt to disguise and dissociate himself from a real dependence upon it—it is possible that his deeper interest in color in the later 1870's and, even more, his sensitivity to the difficulties it posed, may have stemmed from his knowledge, direct or indirect, of Impressionism's almost total reliance on color and color relationships. While his paintings of the 1870's are not immediately reminiscent of Impressionism, his "bumptious" and "noisy" colors and more daring color harmonies may have originated, or at least found support, in the practices of Impressionism.

The relationship between Inness and the French Impressionists is a tentative one at best, not only because there is no definite evidence to support it, but because there may be other influences than Impressionism.

Inness was strongly opposed to artists whom he felt believed "the material is the real." Therefore, the archrealist Gustave Courbet (1819–77) should not have held any attraction for him. But his remarks about Courbet are quite temperate: he found in him "a strong poetic sense" and admired his "robust ideas," [112] and he seems to have been affected by Courbet's style. In the mid–1870's, several of his paintings (*Ills. 49, 55*) are strikingly like Courbet's landscapes, particularly in their deep, rich colors (especially the greens) and succulent paint quality. Another possible influence on Inness's color at this time is that of the English painter J. M. W. Turner (1775–1851). There is no conclusive evidence for this; in fact, as was the case with Impressionism, Inness's remarks about Turner seem to mitigate against it. In 1878, he called Turner's *Slave Ship* "the most infernal piece of clap-trap ever painted," and also, using terms oddly similar to ones applied to his own art at this very time, said that "it is not even a fine bouquet of color. The color is harsh, disagreeable, and discordant." [113] Nevertheless, as early as 1865, his style was linked to Turner's, and he was even referred to, in 1879, as "The American Turner." [114] There is little obvious similarity in the work of Inness and Turner, but it is curious and perhaps significant that in 1878, the very years in which Inness's new colorism was most noticed, he inscribed bits of poetry on the frames of

his Academy pictures, which reminded two critics of Turner's similar practice. He "has taken a leaf from the notebook of Turner," said one, "but it is rather a literary than an artistic leaf." [115] More generally, there seems to be a community of spirit between Inness and Turner, for their art underwent a similar development from an early interest in the old masters to a late style of great freedom of handling, abstract form, and daring color. Both also were impressed by and sought to express the meaning and drama of nature and not merely its appearance. Charles De Kay believed that Inness would eventually recognize his affinity to Turner, stating that his "contempt for the 'Slave-Ship' is so great that one is half persuaded that there is self-illusion at the bottom, and that some day Inness will awake to the fact that the picture which shocked him so much is just the picture he would prefer out of all the other eccentricities of Turner." [116]

It has already been noted that in 1875 Inness was writing a book about art. It does not survive (if it was ever finished), but perhaps the nature of its subject is revealed in the reminiscences of the artist and former American consul in Rome, D. Maitland Armstrong:

> I once met him in the White Mountains and we spent several hours talking together, or rather he talked and I listened, about a theory he had of color intertwined in a most ingenious way with Swedenborgianism, in which he was a devout believer. Toward the latter part of the evening I became quite dizzy, and which was color and which religion I could hardly tell! [117]

Therefore, Inness's interest in color at this time, rather than having been stimulated by the French Impressionists, Courbet, or Turner, could as well have resulted from his endeavor, through color, to make his art explicitly contain and express the ideas of Emanuel Swedenborg, of which he had been a conscientious student since his introduction to them about a decade before at Eagleswood, but for which he had not yet found an artistic outlet.

For one reason or another, then, color was a prime factor in Inness's art of the 1870's. It was not, however, the only one, for we have already noted his freer brushwork and looser form. Also found in several paintings of this period (*Ill. 56 and Plate V*) are compositions of an abstract, decorative, and two-dimensional character, in which visual concerns prevail over narrative content, and which suggest some contact with Japanese art or with Western art influenced by it—that of James A. McNeill Whistler (1834–1903), for example.

Following the decade of the 1860's, during which his main preoccupation was with content, Inness in the 1870's returned to the consideration of formal

questions. But he did not ignore meaning. Rather, he began to examine the possibility that not only could his art be meaningful, as it had been in the 1860's, by portraying nature in its most dramatic states, but that meaning could reside in and be communicated by certain properties of artistic form. Discussing the large and as yet unfinished *Pine Grove of the Villa Barberini, Albano (Ill. 60)*, on September 14, 1875, a writer in the *Boston Advertiser* made these observations:

> It seems to be but an attempt to fathom and reduce to rule the mysterious and infinitely-varying arrangement of the landscape, whereby nature presents to us a scene which attracts and pleases; it appears to be an illustration of the laws of harmony in landscape as resolved and applied by our understanding of things. There is little real nature in it, and an artist who does not have for his teacher the master of the old masters, nature, and nature alone, falls far short of a high aim in his profession. Pictures, no less than poems, do not admit of construction by rules of logic and mathematics.

The composition of the painting is striking and, though derived from the peculiar features of the landscape and stone pines of the Villa Barberini at Albano (as the *Advertiser* critic was perhaps unaware), is also somewhat exaggerated and artificial. It consists of a sharp diagonal division of the picture into two almost equal parts of earth and sky, solid and void, light and dark—a division so emphatic that it must, one feels, have had some larger meaning for Inness. This feeling is reinforced when one recalls that it was also very likely that Inness in 1875 was contemplating the possible relation between the doctrines of Swedenborg and color; pictorial construction or design may have held some similar religious significance for him. Charles De Kay said precisely this in 1882: "Back of the landscape, in whose confection rules founded on logic that can be expressed in the mathematical terms have been strictly followed, lies the whole world of immaterial spirits, of whom Swedenborg was the latest prophet." [118]

The vigorous, exploratory character of Inness's art of the 1870's, though it had been present for some time, became visible—and commendable—to his critics only later in the decade. A writer in *The Century* said of his paintings at the 1877 Academy exhibition: "Inness should be especially praised as one of our older artists who has not fallen into the ruts either of ignorance or indifference. The landscapes of no painter in the exhibition, young or old, are so luminous, so full of vitality. The artist has lost none of the force, and what is still more remarkable, none of the curiosity of youth." [119] In 1879, the *New*

York Times commented, "George Inness has been working with more than his usual energy and persistence," [120] while the *New York Tribune* said, "he explodes again in one of his landscapes." [121]

New York was at this time in a state of artistic ferment generated by a group of young artists who, in 1877, joined together as the Society of American Artists in open rebellion against the National Academy of Design. Their revolt was triggered by the discriminatory policy of the Academy in hanging their paintings, but its roots lay deeper, in a fundamental incompatibility between their ideas of artistic form and content (which they absorbed as art students in Munich and Paris) and those of older academicians. The principle uniting members of the Society was "that art legitimately concerns itself only with the felicitous arrangement of color and line; that its only proper aim is technical excellence and its only fit audience connoisseurs. . . . Art . . . is decorative in its functions . . . its only proper prerogative is to please persons who are in sympathy with it by the exposition of lineal and chromatic beauty; and as such it is an end in itself." [122] On the contrary, the older generation of American painters who formed the establishment of the Academy would agree with Thomas Cole that "the language of art should have the subserviency of a vehicle." [123] The Society's challenge to the authority and beliefs of the Academy was by no means fatal to it, but in the later 1870's, these young artists and the position they represented achieved sudden celebrity, and there was an intoxicating feeling of liberation and novelty in the air. It was a feeling shared by Inness, who was in a good position to follow closely the activities and views of the younger artists, for both his son, with whom he shared a studio from 1876 to 1878, and the sculptor Jonathan Scott Hartley, who became his son-in-law in 1879 and who occupied an adjacent studio, were members of the younger generation. Thus, Inness, who had for so long stood apart from the prevailing American styles, suddenly found himself in congenial company, and his art no longer seemed so out of place and singular. As Clarence Cook noticed in his review of the first Society of American Artists exhibition in 1878, speaking of William Morris Hunt (1824–79), La Farge, and Wyant as well as Inness: "In old Academy exhibitions these pictures would have looked strange and foreign. Here, they are quite at home, and American enough, and we can judge them fairly because we can compare them with work of their own kind." [124] Inness benefited from the new acknowledgment of technique and aesthetic pleasure that the younger painters brought into being, and the formalism for which he had once been so consistently criticized now became a virtue rather than a fault. He had been isolated from his contemporaries not only by his devotion to style, but also because his artistic language, despite the changes he worked upon it,

derived unmistakably from French prototypes. By the later 1870's, however, the chauvinistic American temper that regarded this as a serious fault had been replaced by a cosmopolitan one that looked upon foreign influence less as an indictment than as an indication that American artists could successfully compete with their European counterparts.

The artistic atmosphere of New York in the later 1870's, then, was mostly a beneficent one for Inness—a fact that may to some extent explain the investigative, energetic character of his art at this time. The most conspicuous difference between the younger generation of painters and their predecessors was not foreign training, feelings about technique, or painting style, but rather subject matter. "So far as relates to choice of subject," the critic S. G. W. Benjamin wrote in 1880, "the present movement . . . is not so much toward progress in landscape painting as in the study of the human figure; and this is indeed a great and noble step in advance, for, with the exception of a few rarely good portrait painters, our art has been astonishingly weak in dealing with the higher subject that offers itself to the artist." [125] Throughout his earlier career, Inness had included figures in his landscapes, but always as accessories. Beginning about 1879, however, figures assumed a larger importance, and simply a larger size, in his canvases (and in his thoughts as well, judging from the considerable attention he gave to the subject of the nude in an interview printed in *The Art Journal* in 1879). His interest in the figure was to some degree prompted by the example of the younger painters, but more strongly by the fact that landscape painting was rapidly waning in popularity. Inness's reputation, by now quite formidable, was, with this radical change of taste, threatened with ruin. In 1881, he expressed his financial and emotional desperation in two letters to his wife: [126]

> I am much stronger in many ways than you think. It is not so much the body as it is the discouraging anxieties which I have had to endure, and which come over me at every landscape that I complete. It seems to say, what use am I? It is therefore desirable that I get myself firmly fixed in this painting of figure and overcome the tendency to an old sympathy.

A week later he wrote of his figure paintings: "I think these things will bring money readily, and I am determined to get out of debt this winter, and the sale of landscapes is too uncertain." Inness's figure paintings sometimes have charm (*Ills. 64, 65, 69*), but they are by no means his best works. It was not easy for him to adapt to this new trend, and the period of his extensive and prominent use of the figure is therefore mercifully a short one, ending about 1884. Moreover, the sudden fashion for figural subjects that seemed so ominous

to Inness in 1881 ultimately proved to be to his advantage, since, with fewer landscape painters at work, his attainments in this genre became increasingly conspicuous, and his reputation, once so threatened, grew even greater.

The critical response to Inness's art during the last decade of his life was, almost without exception, adulatory. He was unhesitatingly characterized as America's and, on occasion, even the world's greatest landscape painter. Also, he at last prospered from his art, his fortune equaling his fame. However, persistent physical and psychological problems plagued him. Inness and others remarked on his indigestion, dyspepsia, and rheumatism. He traveled widely for his health (to California, Mexico, and Nantucket), and during the last years of his life spent a considerable portion of each year at Tarpon Springs, Florida, where he had a house and studio. In addition to his physical ailments, and in spite of the artistic and financial success of his later years, he apparently suffered serious periodic attacks of despondency. "While living in Montclair, N.J.," the *New York Tribune* reported after his death, "he frequently gave way to fits of depression and melancholy, much to the alarm of his friends." [127] Inness's final trip to Europe in 1894, in the course of which he died, was made to restore the "tranquility of his mind." [128]

If his physical strength, which was never very great, slackened in his later years, his artistic powers remained undiminished. In fact, they grew greater, and his art in these last years assumed a quality of resolution and conviction that it had never before possessed.

We have followed Inness's art through several stages. From 1844, when he first exhibited at the Academy, until 1853, when he left for his second trip to Europe, his composition, color, and handling of paint conspicuously followed the pattern of seventeenth-century landscapes. After 1854, his allegiance shifted to the looser brushwork, more informal subjects and compositions, and more natural colors of the Barbizon School. From 1854 to about 1860, his concern was primarily the mastery of this style, while from 1860 to 1870, he was interested in the capacity of landscape painting to convey the mystical significance of nature. From 1870 to about 1884, he was engaged in energetically investigating a number of problems; some, such as figure painting, were new to him, while others, involving color, design, and brushwork, constituted more sophisticated reexaminations (perhaps stimulated by recent experiences in Europe) of qualities he had explored earlier.

To many critics the most apparent feature of Inness's art was its variability in style, subject matter, and quality. George P. Lathrop said, "you do not know what to look for in Mr. Inness next." [129] In 1867, Henry Tuckerman remarked that "there is in him a provoking want of sustained excellence, a spasmodic

rather than a consistent merit." [130] James Jackson Jarves said in *The Art-Idea* (1864) that Inness was "wildly unequal and eccentric." [131] Montgomery Schuyler relates how the phenomenon of Inness's variability "was felicitously put by Henry Ward Beecher . . . when somebody asked him who he considered the first of American painters. 'Inness,' unhesitatingly answered the preacher. 'And who is the worst?' 'Inness' came again, with as little hesitation." [132]

The unevenness of Inness's earlier art, whether caused by insufficient training, as some believed, or by the "unconquerable nervousness of his disposition," [133] as others thought, is undeniable. Moreover, in 1878, Inness himself acknowledged the inconsistencies in his art, saying: "Our unhappinesses arise from disobedience to the monitions within us. Let every endeavor be honest, and although the results of our labors may often seem abortive, there will here and there flash out from them a spark of truth which shall gain us the sympathy of a noble spirit." [134] In 1884, he defended the quality of variability in his painting: "I have changed from the time I commenced because I had never completed my art and as I do not care about being a cake I shall remain dough subject to any impression which I am satisfied comes from the region of truth." [135] In Inness's late paintings, however, there is a unity of style that directly reflects the end of his search, the resolution of his experimental efforts. Prior to his late period, he had investigated form and content separately; in it, pictorial form and meaning became inseparable, neither fully coherent without the other. In general, the pattern of his late art displays a new sense of unity, with its ideological and formal elements brought together in a harmonious mixture.

No precise date marks the beginning of Inness's late period, but, for a number of reasons, the year 1884 may be taken to inaugurate this final phase. In 1884, a large and partly retrospective exhibition of Inness's art was held, indicating that it had by then reached a commemorative point. Also, by about 1884, one can unmistakably detect the traits of style that distinguish Inness's late works (*Ills. 70, 71, 74, and Plate VIII*)—for example, abstract clarity of composition, rich though restricted colors, dense atmosphere, and a quiet mood. Finally, 1884 conveniently begins the last decade of Inness's life.

Regardless of exactly where one chooses to mark the beginning of his last phase, it seems that Inness himself was aware that a basic change had taken place in his art some time between the early and the late 1880's. In 1889, General Rush C. Hawkins, the commissioner for the representation of the United States in the Paris Exposition of that year, asked Inness to contribute one of his works. When he refused, Hawkins borrowed *A Short Cut, Watchung Station,*

New Jersey, of 1883 (*Ill. 68*), from a gallery. Inness vehemently protested Hawkins's action in the newspapers, saying that he did not want "an unimportant, non-representative work"[136] to be shown at Paris. Through his wife, he even circulated a petition among the members of the jury of selection (who had unanimously approved Hawkins's choice),[137] but to no avail, for the painting went to Paris and, probably more to Inness's annoyance than pleasure, won a gold medal. While his motives for not wanting to exhibit in Paris were mixed, surely the major one was that, as he himself indicated, he did not want to be represented by a painting, done six years earlier, that he felt no longer characterized his work (compare *Ills. 68 and 76, 77*).

The basic features of Inness's late style were described by Charles De Kay in his 1882 article in *The Century*. De Kay's historical and critical observations, despite some journalistic superficiality and exaggeration, constitute to this day the most perceptive analysis of Inness's art, and the pattern he sketched for its development is, with slight modification, the one still usually applied to it. De Kay posited three vaguely demarcated stages in Inness's art prior to the time he wrote his article: an antewar period, a war or Italian period, and a postwar style. But he also took a broader view of Inness's style, observing two, not three phases: "If big words are not out of place, the present may be called his synthetic style as opposed to the analytic of the days before the war."[138] Inness's earlier art—at least that produced before the early 1880's rather than before the war—is indeed analytic, in the sense that he investigated a variety of problems, and if he did not always paint directly from nature, he preserved its appearance and stated his findings and beliefs in terms of it. His later work is synthetic, first, in possessing a unity of form and content (two aspects that had previously been expressed and explored in isolation), and second, in being more obviously and entirely invented, less dependent in fact or in appearance upon visible reality.

In addition to supplying a critical terminology and criteria for understanding the character of Inness's late paintings, De Kay uncovered a spiritual dimension in them that more recent criticism has largely overlooked: landscape meant for Inness not only "the nature that we see and the human feelings that move us when we look on nature, but something that included both. It is an expression—feeble enough, to be sure, but still an expression—of the Godhead."[139] Relating this to the synthetic character of the late works, De Kay continues: "In the mind of Inness, religion, landscape, and human nature mingle so thoroughly that there is no separating the several ideas."[140] He indicates how this synthesis was accomplished and made apparent, saying: "You may learn

from him how the symbolization of the Divine Trinity is reflected in mathe-
matical relations of perspective and aerial distance." [141] In other words, De Kay
indicates that Inness's late works not only have religious meaning, but that
they express it now not, as in the 1860's, through subject matter only but
through formal configurations as well.

If his canvases are not simply charming or poetic landscapes, so Inness him-
self was more than a mere painter of pretty pictures. He was a thoughtful and
intelligent artist; Elliott Daingerfield, who knew him well during the last
decade of his life, said that "his mind . . . was ever delving into or solving
problems connected with what he called 'the principles of painting.' " [142] It
is not easy to determine, and far less easy to describe, what these principles
were. Inness seldom made explicit theoretical pronouncements, and when he
did, it was in language that nearly obscured his meaning. But despite these
difficulties, some attempt must be made to set forth the salient points of Inness's
artistic thinking, both because he attached considerable importance and devoted
considerable energy to it over a long period of time, and because the character
of his late art is closely bound up with ideas and aspirations that he expressed
in theoretical terms even before they were embodied in his paintings.

Inness's strongest conviction was that art must not simply imitate objective
appearances but that it must attempt to disclose the more significant reality be-
hind them: "The artist reproduces nature not as the brute sees it, but as an
idea partaking more or less of the creative source from which it flows." "How
sweetly, when the animal-mind has been subdued, is the chastened spirit
charmed with the hidden story of the real." [143]

Art, he felt, must have meaning, but that meaning must not be expressed
symbolically, literarily, narratively, or dramatically. Even subject itself was
meaningless: Frederic Edwin Church wrote from Thomasville, Georgia, on
March 18, 1890, that "Geo. Inness is here and thinks it attractive for the artist
—As his theory is 'Subject is nothing, treatment makes the picture' I can be-
lieve he is satisfied." [144] Thus, "treatment" was the primary vehicle of meaning.
After giving a Swedenborgian interpretation of Delacroix's *Triumph of Apollo*
(a ceiling decoration in the Louvre), Inness said: "It is a splendid allegory,
painted with immense power, but, of course, with no attempt to realize nature,
to represent what we see." [145] The symbolism was not offensive to him because
it was rendered in a broad, painterly style that removed it from the realm of
mere storytelling. For it is when things are transcribed too precisely that "you
get a linear impression only, and produce a work more or less literary or
descriptive." [146] For Inness, then, a broadly painted picture hinted at meanings

beyond the things represented: "You must suggest to me reality—you can never show me reality." [147] He described how stylistic breadth could be meaningful, and what sort of meaning it could express:

> . . . we find that men of strong artistic genius, which enables them to dash off an impression coming, as they suppose, from what is outwardly seen, may produce a work, however incomplete or imperfect in details, of greater vitality, having more of that peculiar quality called freshness, either as to color or spontaneity or artistic impulse, than can other men after laborious efforts. . . . Now this spontaneous movement by which he produces a picture is governed by the law of homogeneity or unity, and accordingly we find that in proportion to the perfection of his genius is the unity of his picture.[148]

Painterly breadth had for him the aesthetic virtue of freshness, but it also had an expressive vitality and produced a formal unity that was the reflection of some universal law of homogeneity or unity. Unity achieved through such a spontaneous, unconscious process became an artistic manifestation of a fundamental condition of nature and of all existence, as De Kay indicated when he spoke of Inness "working in that rapt condition of mind during which the lapse of time is not felt, in which the mind seems to extend itself through the fingers to the tip of the brush, and the latter, as it moves on the prepared surface, seems to obey the general laws of nature that fashioned the very landscape that is being counterfeited at the instant." [149]

Even from these few remarks, it seems safe to describe Inness as something of a mystic, despising the material world and working to capture the universal laws of nature. His painting practice seems only to fortify this impression. He felt no need or obligation to work directly from nature, and did not do so regularly. Daingerfield said "the greatest of his pictures were painted out of what people fondly call his imagination, his memory—painted within the four walls of the room, away from and without reference to any particular nature; for he himself was nature." [150] There are, too, many stories and descriptions of the frantic, almost ecstatic intensity with which he painted, working without thought or reflection, as though to seize some fleeting visionary insight.[151]

But to describe either Inness or his art as mystical is to misconstrue both badly. De Kay talked about the logical and mathematical rules that underlay Inness's paintings, and one of Inness's students told how he "talked on structural forms, dimensions, distances, spaces, masses, and lines. . . . One might have thought he was an architect laying out a large structure." [152] Furthermore, despite everything Inness said about the worthlessness of "mere imitation," he attached great aesthetic and expressive value to sensory experience. He

once criticized a painting by saying, "It is silly—neither nature nor good Art. Correctness of linear design it may possess, but further than that it has no beauty at all; it has neither colour, distance, air, space nor *chiaro-scuro*—none of the elements that make a work of Art beautiful or desirable." [153] "Let us endeavor," he said, "to clothe or illustrate an idea of the mind or thought in a form fitted to material comprehension." [154] "I acknowledge that it is the mission of Art to appeal to the mind through the senses. . . ." [155] "Poetry is the vision of reality. When John saw the vision of the Apocalypse, he *saw* it. He did not see emasculation, or weakness, or gaseous representation. He saw *things*, and those things represented an idea." [156] "There is a notion that objective force is inconsistent with poetic representation. But this is a very grave error. What is often called poetry is a mere jingle of rhymes—intellectual dishwater. The poetic quality is not obtained by eschewing any truths of fact or of Nature which can be included in a harmony or real representation." [157]

The reconciliation of subjectivity and objectivity, these contradictory, even seemingly incompatible, conditions, was the major ambition of Inness's thinking and of his art. He said that "whatever is painted truly according to any idea of unity as it is perfectly done possesses both the subjective sentiment— the poetry of nature—and the objective fact." [158] "If a painter could unite Meissonier's careful reproduction of details with Corot's inspirational powers," he said enviously, "he would be the very god of art." [159] The work of art as Inness conceived it does not imitate natural appearances nor does it, through symbol or allegory, allude to the supernatural; it is the reflection of neither the natural nor the supernatural but is an object with an identity and formal integrity of its own in which the two realms meet and interact, in which intangible truth is made real and palpable and reality is perfected and suffused with meaning.

This condition is not to be found in all of Inness's art. It does not even characterize his art of the later 1870's, when his theoretical views were made public. His paintings of this decade (*Ills. 62, 63*) have great beauty and energy of form—particularly in paint handling and color—but it is still the subject rather than the form that is most meaningful; one is more affected by an experience of nature amplified by art than by an experience of art made credible by certain traits of nature. Only in the later 1880's did his art assume the characteristics described by his theory.

The most evident feature of Inness's late paintings (*Ills. 75–94 and Plates VII, IX, X*) is their atmospheric effect, in which all things are enveloped by a thick mist. This is not an effect derived from observable phenomena, for there is more color than would be found in fog or mist, and while in reality fog obscures the substance of objects and flattens space, this does not occur in

Inness's paintings. Their heavy, dense, misty atmosphere does not resemble the visible characteristics of nature but is an invention—an artificial artistic device that permits him to obliterate detail and stress the general form of objects, and to include them in a single, unified atmosphere. These effects precisely reflect his feelings about the worthlessness of imitation and the necessity of pictorial unity. Breadth of style had for a long time been part of his formal vocabulary, yet only in his late paintings does it conform directly to— indeed, illustrate—his theory. Not only is the atmosphere of these paintings so thick and palpable that it confuses the boundaries that separate objects from surrounding space, but the brushwork, too, does basically the same. The result is that atmosphere is quite similar to the forms of solid objects. They are separable, of course, but more in degree than kind. Inness spoke of "a subtle essence which exists in all things of the material world," [160] and the lack of distinction between an object and its atmospheric enclosure suggests the presence of just such a unifying essence. The unity of his late paintings is therefore not simply visual or formal but demonstrates that in "all things of the material world" there is a unity of essence, a kind of vitalizing, harmonizing spiritual force.

But the atmospheric effect of these paintings can also be equivalent to more familiar effects, for it behaves like natural atmosphere by believably surrounding objects and, while obscuring their details, doing so relatively, causing nearer objects to be clearer than those in the distance.

While their atmospheric effects may seem to make these paintings amorphous, they are in fact very strongly structured. Atmosphere is organized by the placement in it of trees, buildings, and figures that establish distance, scale, and dimension. Furthermore, Inness's compositional organization, operating in both two and three dimensions, is extremely beautiful in purely abstract terms—so much so that design competes with color in aesthetic allurement. It has, indeed, an almost mathematical perfection; objects are placed with such care and precision that they seem to be separated by exactly measured intervals, located on a grid system. Whether this is in fact the case (we know Inness was interested in mathematics) or whether it is simply a matter of innate sensitivity, these paintings are ordered with uncommon perfection. There is no question that these canvases are not imitatively realistic, that their color and atmosphere resemble natural effects only in a most general way, and that their compositions are unnaturally perfect. But, at the same time, color, atmosphere, and pictorial structure behave in a familiar way, and sensations of space and substance exist as they do in nature itself. In other words, these late works are neither imitative nor abstract but compromises, syntheses of

these extremes—to which Daingerfield alluded when he said of Inness that "the slightest suggestion would kindle his vision into beautiful assemblages of compositional forms, expressed with full understanding of air or light or sun or shade." [161] One participates in the mood and almost in the space of these pictures, finding qualities familiar in reality. But one also discovers things that are different: colors that are more intense and more beautiful, spaces and relationships that are more lucid, and a peculiar softness and stillness. They are not simply poetic or evocative works, but provide plausible, absorbing experiences of purer and more perfect states of existence.

For about the last thirty years of his life, Inness was a deep and devoted student of Swedenborg. And we gather from his own remarks, as well as from those of such commentators as De Kay, that his late works had some religious meaning, although precisely how this meaning was expressed or of what it consisted we shall probably never know exactly. Considering Inness's long dedication to and extensive study of the teachings of Swedenborg, however, it would be incredible if they did not exert some influence upon his art. Swedenborg's doctrines derive their authority from his contention that they were divinely revealed to him. He claimed to have been chosen by God, Who appeared before him one night "to explain to men the Spiritual sense of the Scripture. . . . Afterwards the Lord opened, daily very often, the eyes of my spirit, so that in the middle of the day I could see into the other world, and in a state of perfect wakefulness converse with angels and spirits." [162] As a consequence of his privileged admission to the spiritual world, Swedenborg's writings contain many specific descriptions, professedly eyewitness accounts, of its appearance and character, through which it acquires vivid actuality and concreteness: he describes mansions, parks, groves of trees, the garments of angels, and so forth. But he also describes in more essential terms the properties and composition of the spiritual world, and in these we see the relationship to Inness's painting.

A central aspect of the spiritual world is that though it is fundamentally different, it nevertheless closely resembles the natural, material world:

It should be known that the spiritual world is, in external appearance, wholly unlike the natural world. Lands, mountains, hills, valleys, plains, fields, lakes, rivers, springs of water are to be seen there, as in the natural world; thus all things belonging to the mineral kingdom. Paradises, gardens, groves, woods, and in them trees and shrubs of all kinds bearing fruit and seeds; also plants, flowers, herbs, and grasses are to be seen there; thus all things pertaining to the vegetable kingdom. There are also to be seen there beasts, birds, and fishes of every

kind; thus all things pertaining to the animal kingdom. Man there is an angel or spirit.[163]

But if in these respects the spiritual world resembles the natural, in others it differs markedly. Swedenborg reported that "things in the spiritual world are not fixed and settled like those in the natural world, because in the spiritual world nothing is natural but everything spiritual."[164] The Swedenborgian writer Theophilus Parsons (it is likely that Inness read such exegetes) said that "the world we there live in is not the hard, unyielding material world we live in here. We have gone away from the world in which the substance of being is vested in resisting and indurated forms."[165] Swedenborg himself in several places made the distinction between things in the spiritual world that are substantial and those in nature that are material.[166] Parsons wrote that in the spiritual world

> . . . we need space and time that we may recognize ourselves and others, and make use of the things about us; or, in one word, live. But we no longer need *such* space and time as we had in this world: we no longer need their restraint and compulsion, and these pass away; but we do need as much as before their assistance, and that we have. We may express the difference in a few words, thus: In this world, space and time control thought and will; in that world, thought and will control space and time.[167]

Swedenborg remarked that

> . . . since angels and spirits see with eyes, just as men in the world do, and since objects cannot be seen except in space, therefore in the spiritual world where angels and spirits are, there appear to be spaces like the spaces on earth; yet they are not spaces, but appearances; since they are not fixed and constant, as spaces are on earth; for they can be lengthened or shortened; they can be changed or varied.[168]

He said also:

> . . . in the spiritual world there are not material spaces with corresponding times; but there are appearances of time and space; . . . The common opinion about the state of the soul after death, and therefore also about angels and spirits, is that they do not occupy any extension, and consequently are not in space and time. Owing to this idea souls after death are said to be in an indefinite somewhere, and spirits and angels are said to be mere puffs of air, which can be thought of only as ether, air, breath, or wind is thought of; when in fact they are substantial men, and like men in the natural world live together in spaces and times.[169]

Swedenborg wrote, too, that "representations in the other life cannot take place except by means of differences of light and shade."[170] and that "colors

. . . are seen in the other life which in splendor and refulgence surpass the luster of the colors of this world to such a degree that any comparison is impossible." [171]

These few passages are sufficient to suggest how Swedenborg influenced Inness's late paintings, causing them to reflect and embody his religious experiences as no earlier period of his art did. The spiritual world that Swedenborg described was thoroughly believable, structured, and occupied with familiar objects and relationships. So, too, is the world Inness depicted in his landscapes. But the spiritual world is composed of objects that are soft and yielding, formed of substance rather than of matter. This perfectly characterizes the objects in Inness's paintings. In the spiritual world, things exist in a coherent space, yet one in which distances are not fixed and absolute. In Inness's works, nothing that determines distance and articulates space is firmly attached to the ground; he does not stress but, on the contrary, obscures the junction of an object and the surface upon which it supposedly rests, with the result that one may visually or imaginatively will changes in spatial relationships that thereby become "not fixed and constant, as spaces are on earth." This effect is further enhanced by the possibility of reading his paintings alternately as two- or three-dimensional, so that objects and relationships may lie upon a flat surface or be imbedded in space. Inness's colors do not even approach the brilliant hues of the spiritual world as Swedenborg described them. But if they are not dazzlingly bright, they are radiant and lustrous and in this way provide a convincing pigmental equivalent for the "splendor and refulgence" of the colors of the spiritual world.

Inness's late paintings are quite remarkable achievements. In a career not previously wanting in beautiful works, they represent—in their subtle but adventuresome, sometimes even daring, coloration, and in their thoroughly sophisticated design—the high point in Inness's mastery of artistic form. They are shaped, however, not only by an aesthetic sensitivity of considerable magnitude, but by images (and perhaps also by ideas) formulated by his study of Swedenborg's writings, and for the first time reflect Inness's deep religious interests. Qualities of both form and content are at once more evident and more fully integrated than they had been before. Inness's sympathy for pictorial form, which he maintained throughout his career, is now absolutely unmistakable in the colors, textures, and organization—all more abstract than imitative —of these late works. Indeed, in 1894, one of his landscapes was described as "more of a painting than a picture." [172] Yet form became not an end in itself but the servant and communicator of content, content more apparent and meaningful because it was for the first time stated in a language suited to it.

These late paintings are undeniably charming and poetic, but to see this is to see their surface appeal only, and to miss also their position in Inness's *oeuvre* as the finest and most mature expressions of a thoughtful and sensitive artist.

It is abundantly clear that Inness embraced neither the style nor the attitude of the majority of landscape painters who were, like him, born around 1825 and who matured at mid-century. He may have felt the same expansive optimism and national pride as Church, Albert Bierstadt (1830–1902), Gifford, and Cropsey—he was certainly deeply patriotic, as his behavior during the Civil War indicates—but when it came to art they parted company. Their simple faith in the possibility of imitating nature, and in the aesthetic efficacy and moral desirability of doing so, was one that Inness did not share. He certainly loved nature—more in its civilized than wilder aspects, however—but he loved art as much, and not merely as a vehicle but as something with a force and virtue of its own, which when joined to that of nature augmented its beauty. Inness was, quite simply, the champion of Art in an age of Nature. His critics noticed this and took pains to warn him of the dangers of such sympathies. His colleagues saw it too: as early as 1845, Cropsey urged him to study nature,[173] and Inness's slow elevation in the Academy's ranks suggests concerted and official disapproval of his independent position.

It was not only Inness's innate sympathy for form that disturbed his critics and colleagues but also the type of form he ultimately chose: that of Barbizon landscape painting. While he was still imitating the old masters, his critics believed him not beyond redemption, but when he adopted the breadth of the Barbizon style, they reacted with complete disapproval, and he was set even farther apart from the mainstream of American painting. Yet Inness was not the only American artist to be influenced by Barbizon painting. His almost exact contemporary William Morris Hunt, and such younger artists as Alexander Wyant and Homer D. Martin (1836–97), were also touched by it.

Hunt is usually credited with being the first to discover and import the Barbizon style to America; his discovery of Jean François Millet (1814–75) in 1850 antedates Inness's first exposure to Rousseau by two years. By virtue of his attractive personality and social position, Hunt was a powerful and convincing spokesman for the Barbizon style in Boston and left his mark indelibly upon the artistic tastes of that city. Nevertheless, Inness was as much if not more a "harbinger" as Hunt (as Flexner has characterized the latter).[174] It seems irrelevant to make an issue of the two years that separated their first exposures to Barbizon style, particularly since they both returned to America

with this style at about the same time (Hunt in 1855, Inness probably in 1854). And since the Barbizon type of landscape was to be more popular among American artists than the Barbizon figure style, Inness's influence must be counted the greater. Moreover, Inness exerted his influence primarily on artists, while Hunt's influence was greatest on patrons. Most important, Inness was an incomparably stronger artist. Hunt was always the faithful pupil and disciple, incapable of transforming what he learned, first from Couture and then from Millet, into a personal style but continuing to the end of his life to repeat theirs. Inness did for a time submit to the influence of Rousseau, yet he was never his disciple—he did not, as Hunt did with Millet, follow him to Barbizon and dress like a peasant—but learned from his art, and from that of other Barbizon painters, too, for it was the style, rather than the man, that Inness respected. In order to learn, he may have imitated Barbizon subjects rather carefully, but even while doing so, he revealed a more inquisitive mentality that brought to bear upon that style certain personal requirements of taste and expression that slowly but steadily reshaped it, individualizing it in a way that Hunt was never able to do. Hunt's art never grew; Inness's never ceased growing, for he was forever experimenting, expanding its capacity, enriching and refining its form—his purpose being to create an instrument that would fully accommodate his ideas and express his identity.

The same may be said when comparing Inness to such other Barbizon-inspired artists as Wyant and Martin. His is again the more investigative spirit, whose art is freest from its sources, and, in particular examples, more inventively and authoritatively formed. None of Wyant's or Martin's paintings, charming as they are, compare to Inness's in firmness of design and handsomeness of color. They are, too, more obvious in meaning and more literal in appearance, and hence more trivial and transparent than Inness's works. Qualitatively, too, they do not have that simultaneously strong yet subtle two- and three-dimensional design that distinguishes Inness's paintings, especially those of the 1890's.

The American artist to whom Inness is temperamentally and stylistically most related is Albert Pinkham Ryder (1847–1917), and it is a good indication of the progressive character of Inness's art that it may be so easily compared with that of a man more than twenty years his junior. Several qualities relate them: they were both nourished by Barbizon art, yet molded it to their own needs, developing from it, moreover, a simplified, semi-abstract style; both had meditative, reclusive personalities that are reflected in the dreaminess and mysteriousness of their paintings; both were careless technicians, painting impulsively and very often with bad materials, with the result that many of

their pictures are in a ruined condition. During his later life, when his art was most like Ryder's, Inness was publicly admired and at least partially understood, neither his imagery nor his style being so private as Ryder's. But this does not mean that Inness was the lesser talent, only that he and Ryder had different ideas of what art could and should do. For Ryder, it was a very direct means of expression, a means of exploring his visionary world. For Inness, a work of art was not a means but an end; it was on the pictorial mechanism that his energy was concentrated. He did not seek or undergo spiritual experiences in the process of painting but sought to create a suitable artistic equivalent or substitute for them. To put it most broadly—and at once to distinguish Inness from his Hudson River School contemporaries and from the younger Ryder—his art is more detached than theirs, in the sense that it is tied neither to the visible world nor to the artist's imaginary one; it has an identity and formal independence that sets it apart from both fact and fancy yet permits it, in its highest and most perfected condition, to embrace—but not to depend upon—both. Inness comes closer than any of his American colleagues to acting upon Maurice Denis's famous observation that "a picture before it is a war horse, a naked woman, or some anecdote, is essentially a flat surface covered with colors arranged in a certain order." [175]

Inness's late paintings are often compared to Impressionist works. To a certain extent, such a comparison is reasonable, because their delicate colors and indefinite forms are reminiscent of many of Monet's paintings of the 1880's and after. But this view is not really justified, for Inness was unfailingly hostile to Impressionism. He disliked its lack of structure—he spoke of its "pancake of color" [176]—and its realism. His own art was apparently and theoretically not intended to represent tangible reality but was an art of ideas (for which the Impressionists had little sympathy), in which color behaved not in conformity with optical or observable phenomena but according to aesthetic and expressive requirements. If Inness's art had no real relationship to the Impressionism of Claude Monet (1840–1926), Camille Pissarro (1830–1903), and Alfred Sisley (1839–99), this was not because the pre-Impressionist sources upon which he drew prohibited him from understanding and appreciating Impressionism, but because his interests in effect carried him beyond Impressionism.

In many respects his art corresponds more easily to Post-Impressionism, although there are no obvious similarities, and no question of influence. Despite the fact that Inness was many years older than the Post-Impressionists, his art attained fruition at the same time as theirs. It was only around 1885 that his art entered the stage of its highest achievement. It was precisely as this time,

too, that Georges Seurat (1859–91), Vincent van Gogh (1853–90), Paul Gauguin (1848–1903), and even the older Paul Cézanne (1839–1906) arrived at their characteristic styles. There are stylistic as well as chronological similarities between Inness and the Post-Impressionists. In their work, color is liberated from a purely descriptive function so that it may operate aesthetically and expressively. Inness's colors are usually less brilliant than those of the Post-Impressionists; they are, however, just as arbitrary and stem from considerations of beauty and meaning, rather than from the direct observation and analysis of nature.

A common and distinctive feature of Post-Impressionism is its simplification of form, consisting of a reduction to underlying geometry, as in Cézanne, or to two-dimensional flatness, as in Gauguin. Again, this feature is less extreme in Inness's late paintings than in those of the Post-Impressionists, but it is nevertheless true that he so generalizes contours and surfaces that one is as aware of their abstract properties as of their real identities. And if Inness never reduced his compositions to totally flat patterns, it is possible to appreciate them as much for their decorative effects as for their spatial illusions.

One of the unifying elements in the diversity of Post-Impressionist styles is the revived interest in content shared by these artists. While each approached content in different ways, they all rejected the intentional lack of literary and symbolic meaning that was, in their view, one of Impressionism's limitations. Seurat employed combinations of hues, values, and linear directions to elicit moods of gaiety, calmness, or sadness in the beholder. Gauguin, in a less exact, more "musical" way, used color and design to allude to ideas and feelings. And Van Gogh expressed himself both through the meaning he attached to certain colors and through his emotionally charged brushstrokes. Of equal importance, the particular meaning the artist wished his work to have was transmitted only in part through its subject and much more through the various artistic means used. In Inness's late works, ideas and images derived from Swedenborg are neither symbolized nor illustrated but are imbedded in a coloristic, compositional pictorial structure of a distinctly abstract sort; that is, meaning resides in and is communicated by formal means, as it is in Post-Impressionist painting.

It is true that Inness is never as explicit or as extreme as the Post-Impressionists in those areas in which they are related, but it is nevertheless remarkable in how many ways he resembles them. These connections are not made to aggrandize Inness by thrusting him into the company of painters of acknowledged greatness. Rather, they suggest some further dimensions of Inness's style and indicate that an American artist was capable of more than sim-

ply imitating a foreign style and could be motivated, though less overtly and at a different pace, by the insights and aspirations that shaped and characterized advanced French painting of the second half of the nineteenth century and that centered around the nature and potentials of artistic form. Inness, in short, had the sophisticated artistic intelligence of the great French painters. Winslow Homer (1836–1910) shared this quality, and so, too, did Ryder, but Homer disguised it, and with Ryder it was intuitive rather than cultivated. George Inness consciously cultivated it, and made no effort to disguise it.

ILLUSTRATIONS

1. John Jesse Barker. *East Entrance to Rahway, New Jersey.* 1843. Present whereabouts unknown. *Photo Frick Art Reference Library, New York.*

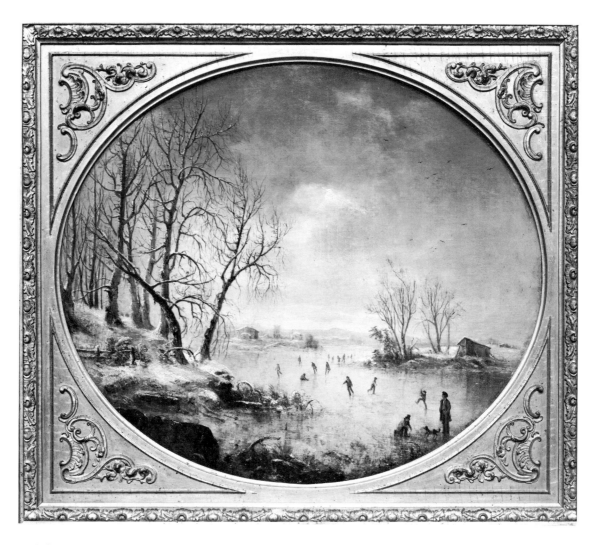

2. Régis François Gignoux. *Winter Scene in New Jersey.* 1847. Oil on canvas, 20 x 24 inches. Courtesy, Museum of Fine Arts, Boston; M. and M. Karolik Collection.

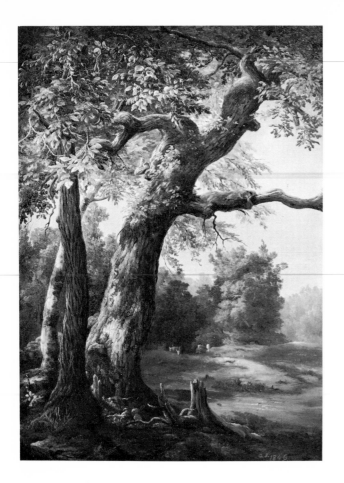

Left
3. *Woodland Vista*. 1846. Oil on canvas, 19¾ x 14¾ inches.
Courtesy, Museum of Fine Arts, Boston; M. and M. Karolik
Collection.

Below
4. *Sleepy Hollow*. 1849. Oil on canvas, 17¾ x 22¾ inches.
Collection Mrs. Albert F. Murray, Jr., Washington, D.C.
Photo Woltz Studio, Washington, D.C.

5. *Our Old Mill*. 1849. Oil on canvas, 29⅞ x 42⅛ inches.
Courtesy of The Art Institute of Chicago; William Owen and Erna Sawyer Goodman Collection.

6. *Landscape*. 1850. Oil on canvas, 30 x 25 inches.
Galleries, Cranbrook Academy of Art, Bloomfield Hills, Michigan.

7. *March of the Crusaders*. 1850. Oil on canvas, 36 x 48 inches.
Fruitlands Museums, Harvard, Massachusetts.

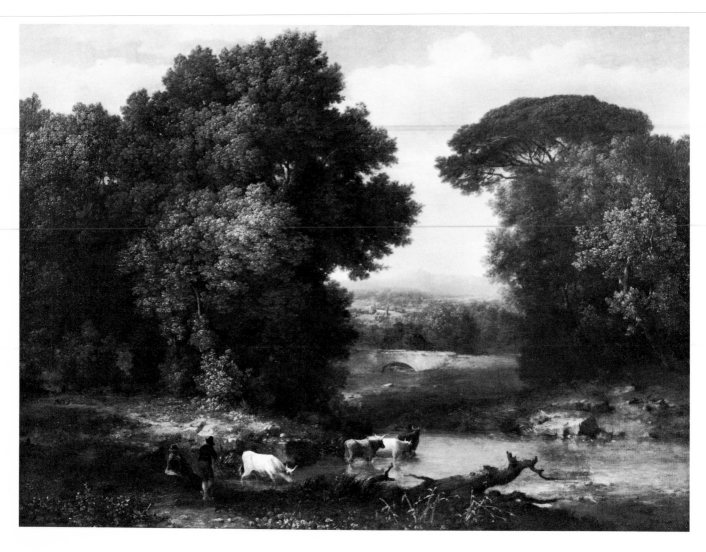

8. *A Bit of the Roman Aqueduct.* 1852. Oil on canvas, 39 x 53¼ inches.
The High Museum of Art, Atlanta, Georgia; Museum purchase with funds from the
Members' Guild of The High Museum of Art, 1969.
Photo Jerome Drown, Atlanta, Georgia.

9. Théodore Rousseau. *Meadow Bordered by Trees. ca.* 1845.
Oil on wood, 16⅜ x 24⅜ inches.
The Metropolitan Museum of Art, New York; Bequest of Robert Graham Dun, 1911.

10. Théodore Rousseau. *Forest of Fontainebleau. ca.* 1860.
Oil on canvas, 62⅝ x 74¼ inches.
Collection, University Art Museum, University of California, Berkeley; Bequest of Phoebe Apperson Hearst.
Photo Ron Chamberlain.

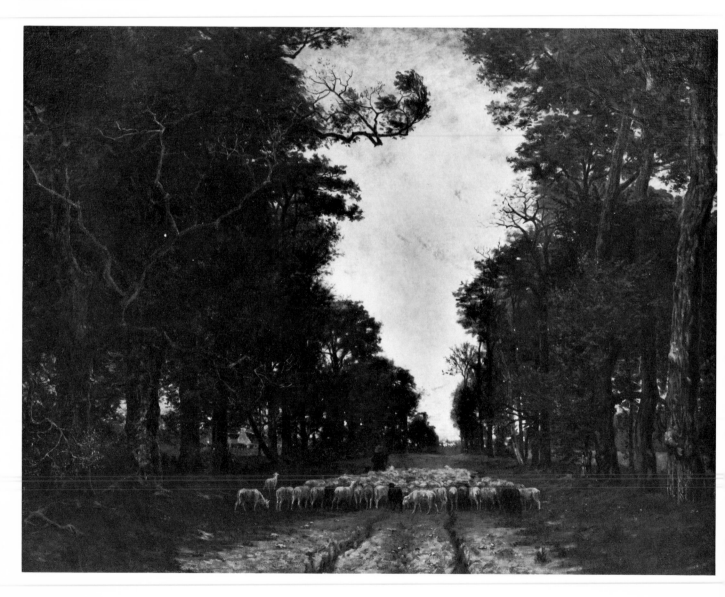

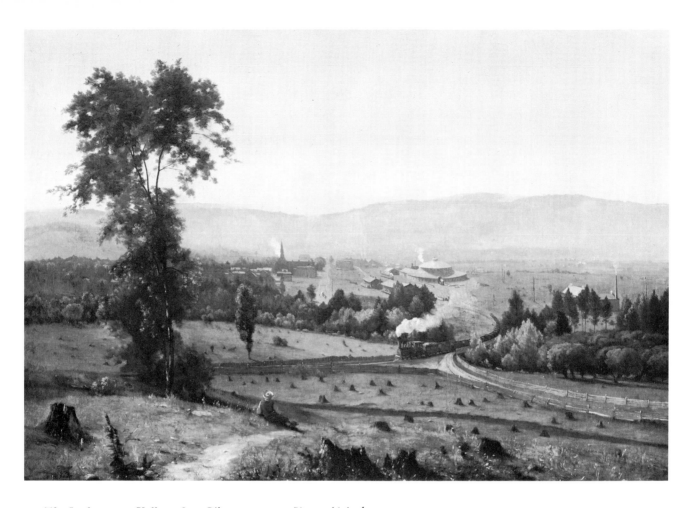

11. *The Lackawanna Valley.* 1855. Oil on canvas, 33⅞ x 50¼ inches.
National Gallery of Art, Washington, D.C.; Gift of Mrs. Huttleston Rogers, 1945.

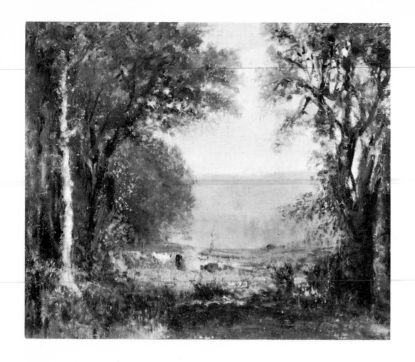

12. *Near the Lake. ca.* 1856. Oil on canvas, 8 x 10 inches.
Vassar College Art Gallery, Poughkeepsie, New York; Gift of Matthew Vassar, 1864.
Photo Peter A. Juley & Son, New York.

Below
13. *Evening in the Meadows.* 1856. Oil on canvas, 9 x 12 inches.
Vassar College Art Gallery, Poughkeepsie, New York; Gift of Matthew Vassar, 1864.
Photo Peter A. Juley & Son, New York.

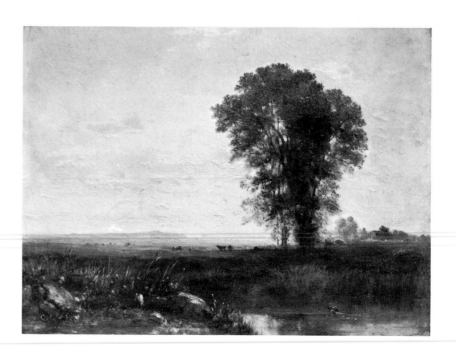

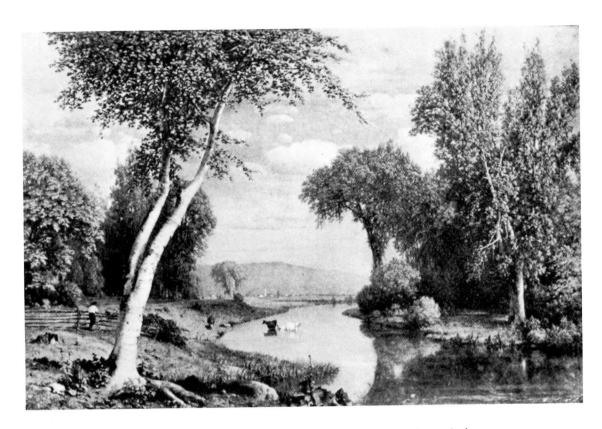

14. *The Juniata River near Harrisburg, Pennsylvania.* 1856. Oil on canvas, 36 x 54 inches.
Present whereabouts unknown.
Photo courtesy Fogg Art Museum, Harvard University, Cambridge, Massachusetts.

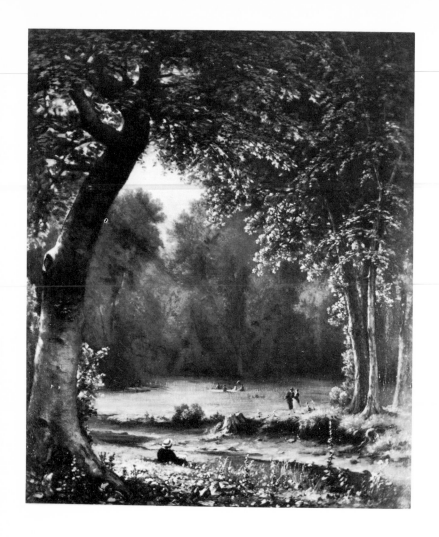

15. *Midsummer Greens*. 1856. Oil on canvas, 24 x 20 inches.
Collection Ann Harrington Skiff, Washington, D.C.

Right
16. *Autumn*. 1856–60. Oil on canvas, 14⅜ x 12⅛ inches.
Museum of Art, Rhode Island School of Design, Providence, Rhode Island.

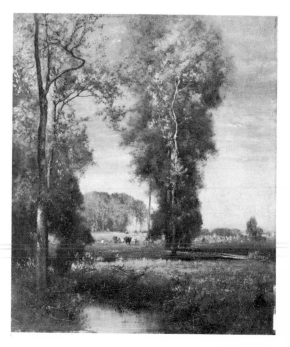

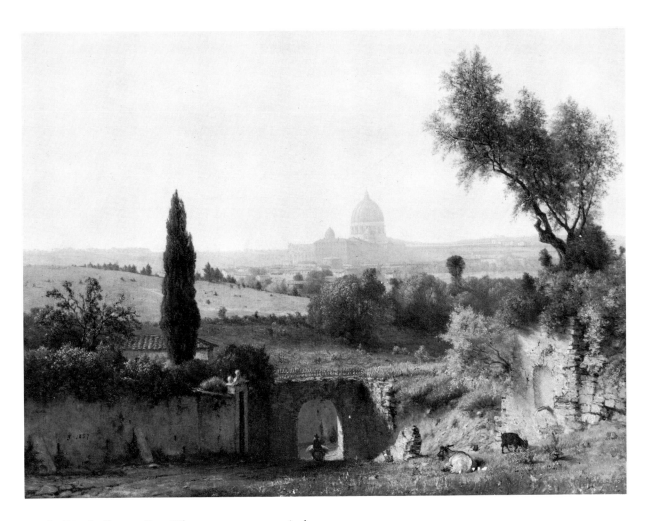

17. *St. Peter's, Rome.* 1857. Oil on canvas, 30 x 40 inches.
The New Britain Museum of American Art, New Britain, Connecticut.
Photo E. Irving Blomstrann, New Britain, Connecticut.

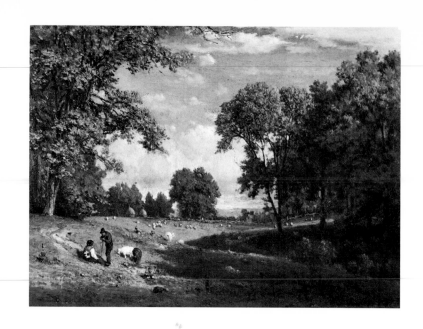

18. *Summer Landscape.* 1857. Oil on academy board, 10 x 14 inches.
Collection Mr. and Mrs. Junius T. Moore, Sr., Charleston, West Virginia.

Below
19. *Hackensack Meadows, Sunset.* 1859. Oil on canvas, 18¼ x 26 inches.
Courtesy of The New-York Historical Society, New York City.

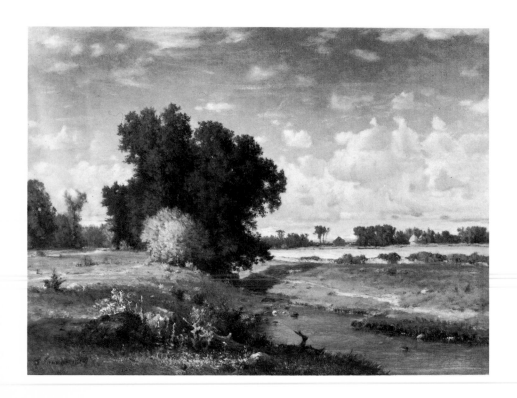

20. *A Passing Shower*. 1860. Oil on canvas, 26 x 40 inches.
Arkell Hall Foundation, Canajoharie, New York.

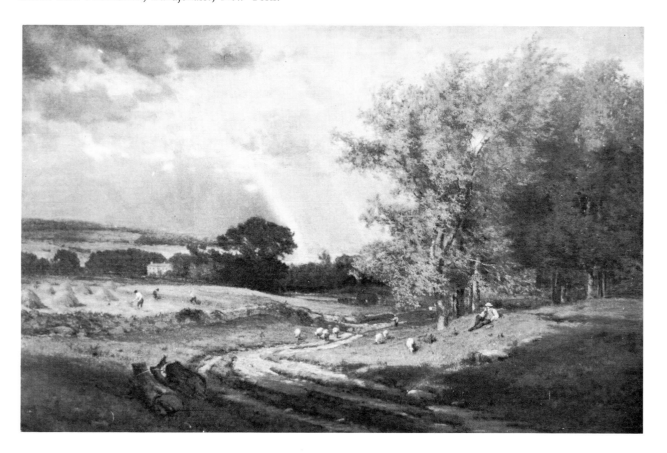

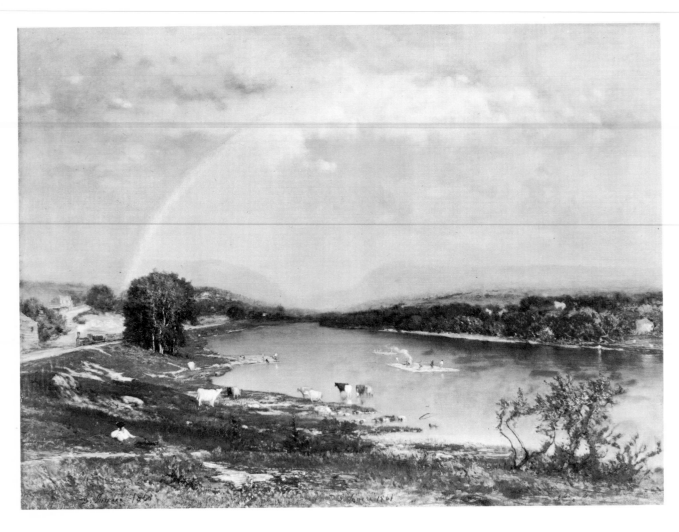

21. *Delaware Water Gap.* 1861. Oil on canvas, 36 x 50⅛ inches.
The Metropolitan Museum of Art, New York; Morris K. Jesup Fund, 1932.

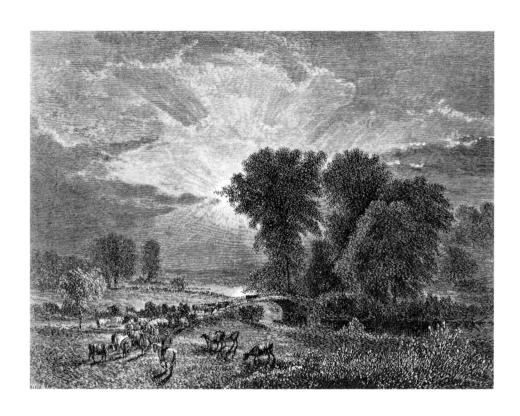

22. *The Light Triumphant*. 1862. Present whereabouts unknown.
Wood engraving from George W. Sheldon, *American Painters,* New York, 1879,
facing p. 31.

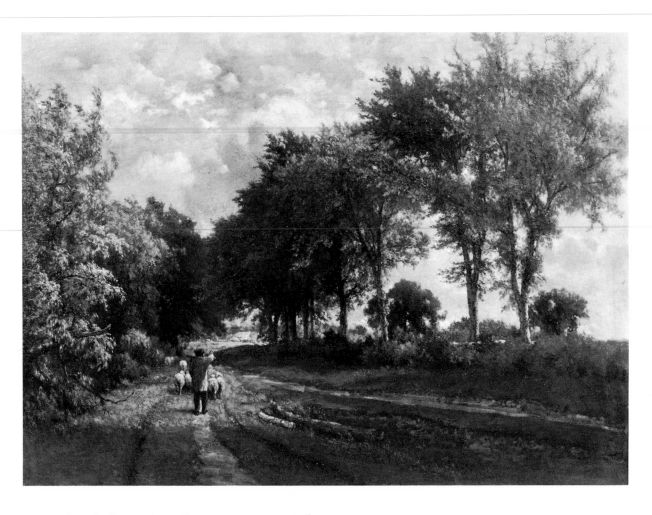

23. *Road to the Farm*. 1862. Oil on canvas, 27 x 37 inches.
Courtesy, Museum of Fine Arts, Boston; Gift of Robert Jordan from the collection of Eben D. Jordan.

24. *Golden Sunset.* 1862. Oil on canvas, 18 x 24 inches.
Cincinnati Art Museum, Cincinnati, Ohio; Bequest of Helen Swift Neilson.

Below
25. *Shades of Evening.* 1863. Oil on canvas, 15¼ x 26¼ inches.
George Walter Vincent Smith Art Museum, Springfield, Massachusetts.

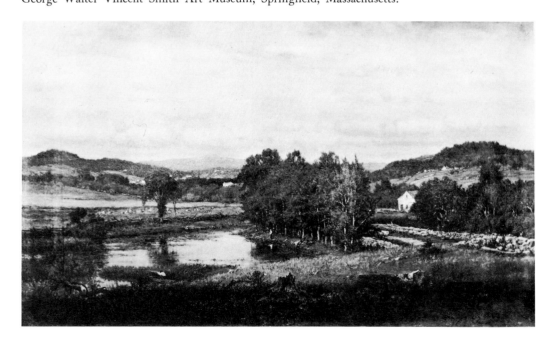

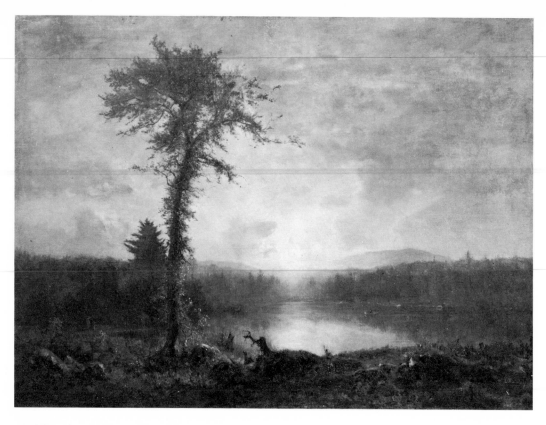

26. *The Close of Day*. 1863. Oil on canvas, 25 x 35 inches.
Collection of the J. B. Speed Art Museum, Louisville, Kentucky.

Below
27. *Landscape*. 1864. Oil on canvas, 12⅛ x 17⅞ inches.
The Columbus Gallery of Fine Arts, Columbus, Ohio; Bequest of Mrs. Virginia H. Jones.
Photo Hugh L. Graves, Columbus, Ohio.

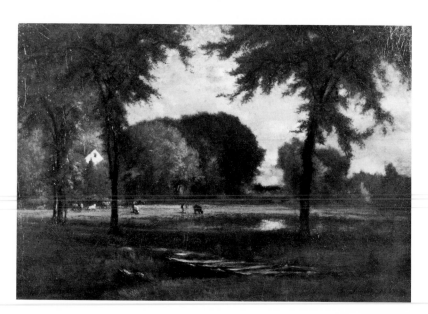

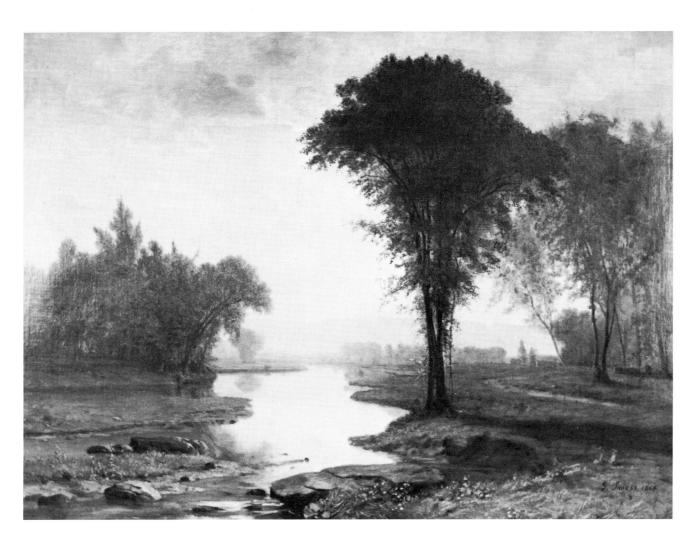

28. *The Elm.* 1864. Oil on canvas, 36 x 50 inches.
University of Maine Art Collection, Orono, Maine.

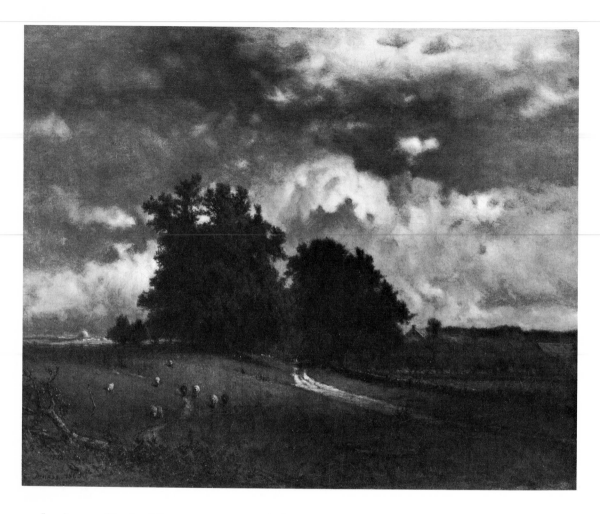

29. *Landscape.* 1863–65. Oil on canvas, 22 x 30 inches.
Pomona College Art Gallery, Claremont, California; Alan Matson Bequest.

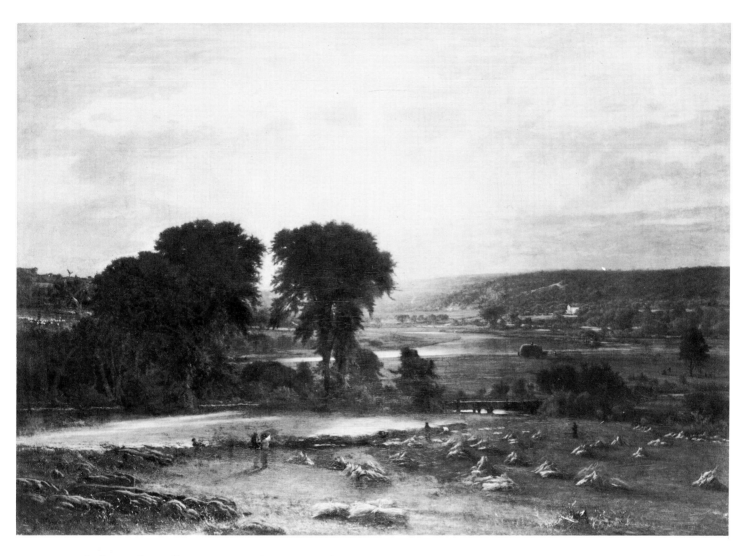

30. *Peace and Plenty*. 1865. Oil on canvas, 77⅝ x 112⅜ inches.
The Metropolitan Museum of Art, New York; Gift of George A. Hearn, 1894.

31. *Going Out of the Woods*. 1866. Oil on canvas, 47⅜ x 71¾ inches. Courtesy of The R. W. Norton Art Gallery, Shreveport, Louisiana.

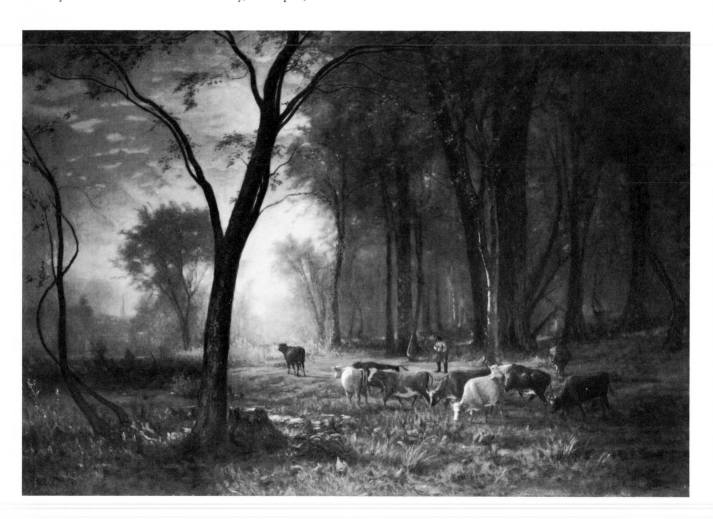

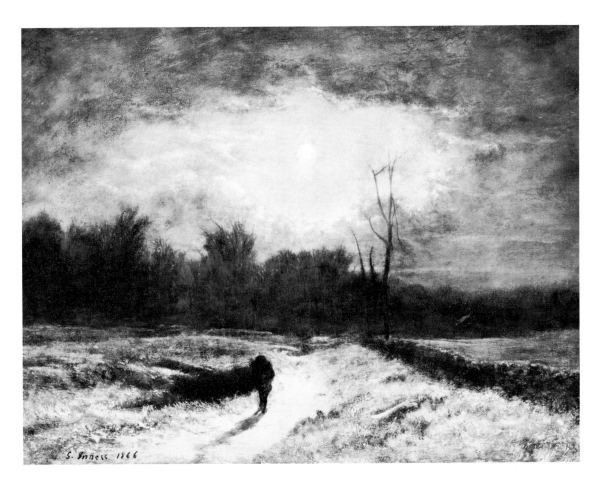

32. *Christmas Eve.* 1866. Oil on canvas, 22 x 30 inches.
Collection of the Montclair Art Museum, Montclair, New Jersey.

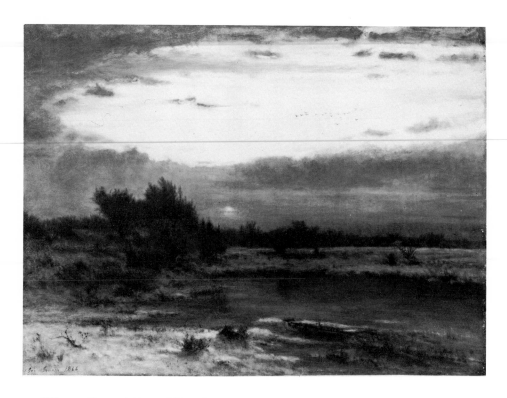

33. *Winter, Close of Day.* 1866. Oil on canvas, 22 x 30½ inches.
The Cleveland Museum of Art; The Charles W. Harkness Gift.

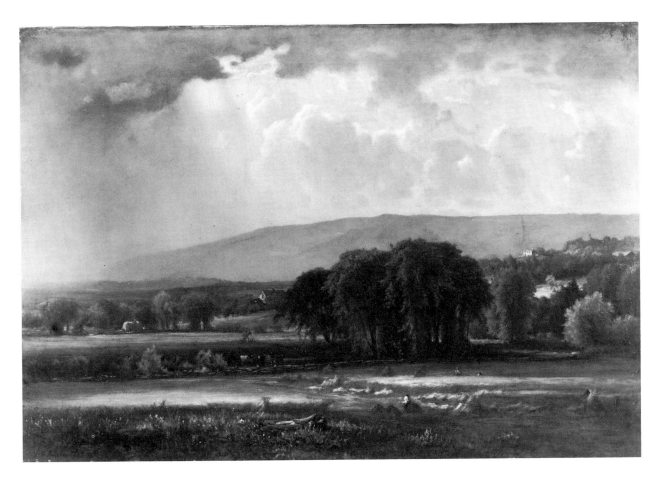

34. *Harvest Scene in the Delaware Valley.* 1867. Oil on canvas, 30⅛ x 45⅛ inches.
Collection Walker Art Center, Minneapolis, Minnesota.

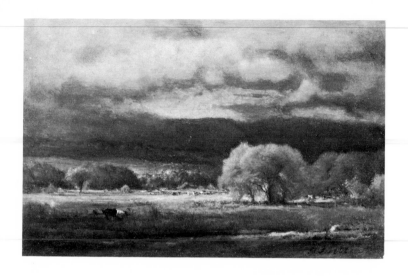

35. *Eagleswood, New Jersey.* 1868. Oil on composition fiber board, 7⅐₁₆ x 11¹⁵⁄₁₆ inches.
Worcester Art Museum, Worcester, Massachusetts; Theodore T. and Mary G. Ellis Collection.

Below
36. *Cloudy Day.* 1868. Oil on canvas, 14 x 20 inches.
Smith College Museum of Art, Northampton, Massachusetts; Gift of Mrs. John Stewart
Dalrymple, 1960. *Photo Herbert P. Vose, Wellesley Hills, Massachusetts.*

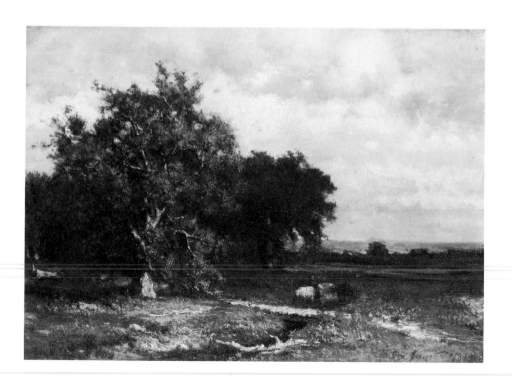

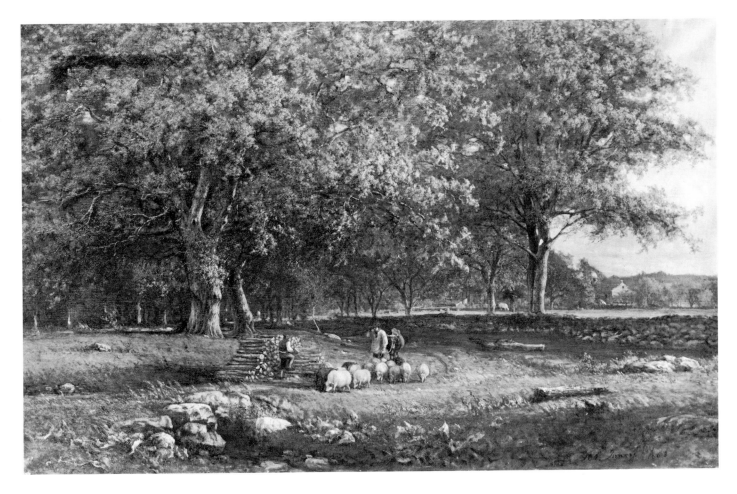

37. *Evening.* 1868. Oil on canvas, 48½ x 78¼ inches.
The Metropolitan Museum of Art, New York; Gift of George I. Seney, 1887.

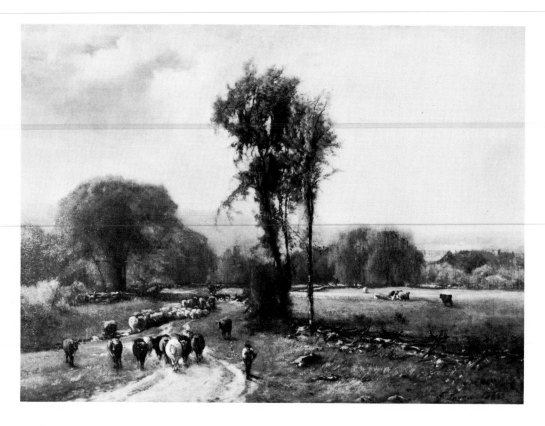

38. *Landscape with Cattle and Herdsman.* 1868. Oil on canvas, 24 x 34¼ inches.
Collection of the Montclair Art Museum, Montclair, New Jersey; Lang Fund.
Photo Lillian Bristol.

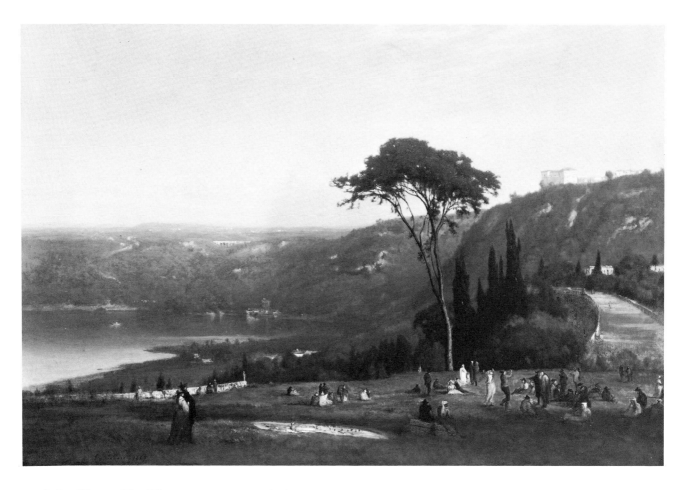

39. *Lake Albano*. 1869. Oil on canvas, 30 x 45 inches.
The Phillips Collection, Washington, D.C.

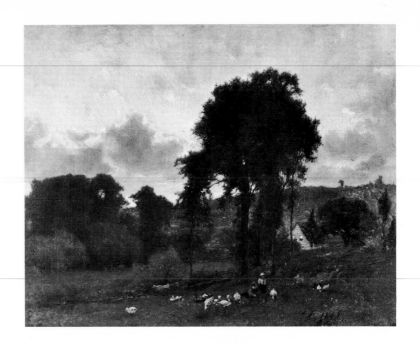

40. *Durham, Connecticut*. 1869. Oil on canvas, 9 x 11¾ inches.
Courtesy of the Fogg Art Museum, Harvard University, Cambridge, Massachusetts;
Bequest of Allston Burr.

Below
41. *Landscape, Sunset*. 1870. Oil on canvas, 15 x 23⅛ inches.
Courtesy of The Art Institute of Chicago; Nickerson Collection.

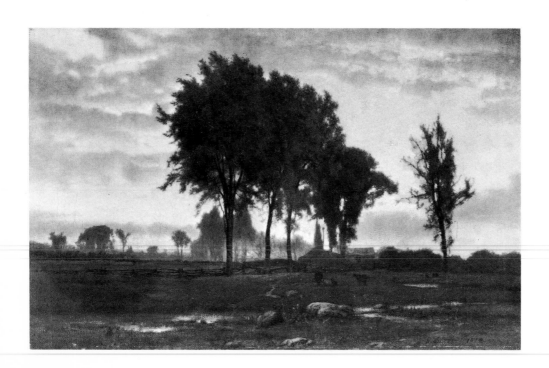

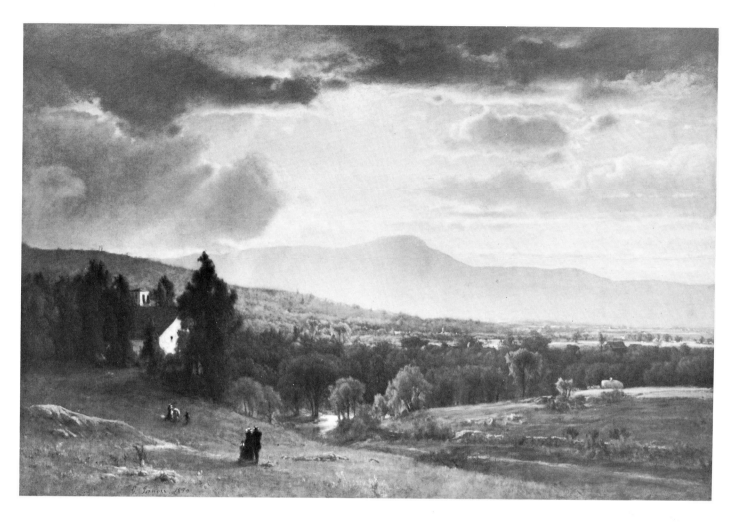

42. *Catskill Mountains.* 1870. Oil on canvas, 48½ x 72½ inches.
Courtesy of The Art Institute of Chicago; Edward B. Butler Collection.

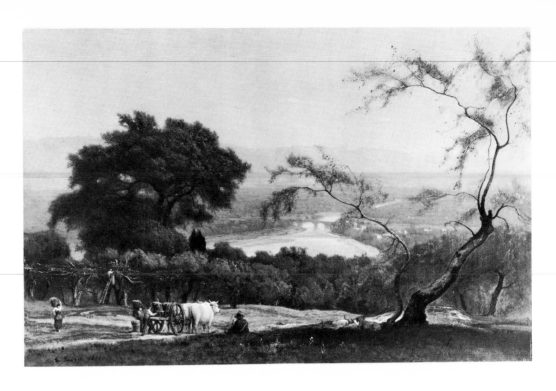

43. *The Tiber Below Perugia.* 1871. Oil on canvas, 21 x 32 inches. The Toledo Museum of Art, Toledo, Ohio; Gift of Arthur J. Secor, 1922.

Left
44. *Tivoli.* 1871. Oil on canvas, 25 x 21 inches. Museum of Art, Rhode Island School of Design, Providence, Rhode Island.

45. *Monte Cassino Abbey*. 1871. Oil on canvas, 38 x 63 inches.
Strecker Museum, Baylor University, Waco, Texas.
Photo Windy Drum Studio, Waco, Texas.

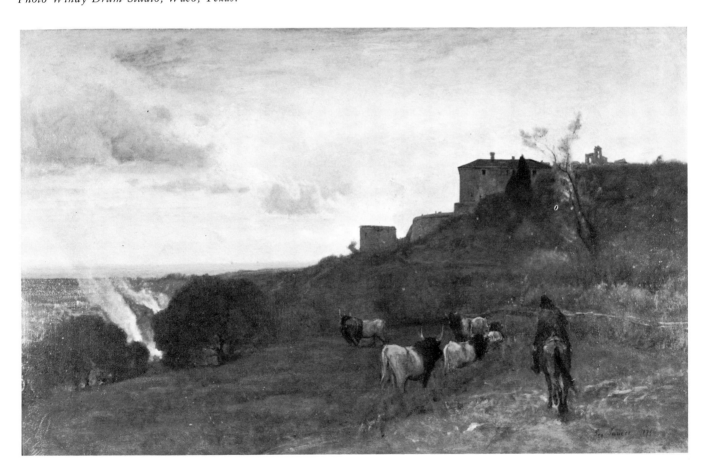

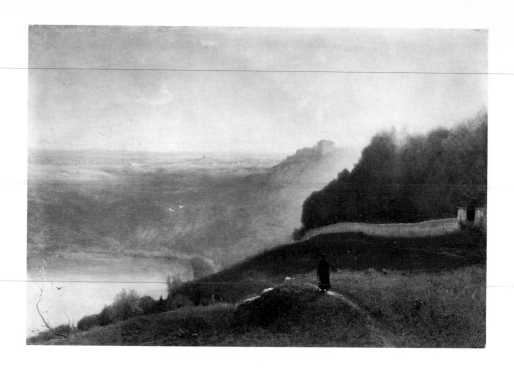

46. *Lake Nemi*. 1872. Oil on canvas, 12¼ x 18¼ inches.
Courtesy, Museum of Fine Arts, Boston; Charles Henry Hayden Fund.

Below
47. *View of S. Giorgio Maggiore, Venice. ca.* 1872. Water color, 5 x 9 inches.
Williams College Museum of Art, Williamstown, Massachusetts.

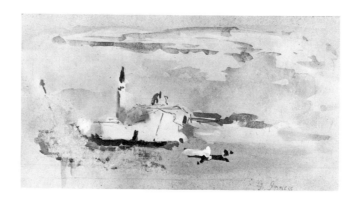

48. *The Olive Grove. ca.* 1872. Oil on canvas, 18 x 25¾ inches.
Collection Professor John Wilmerding.
Photo Vose Galleries, Boston.

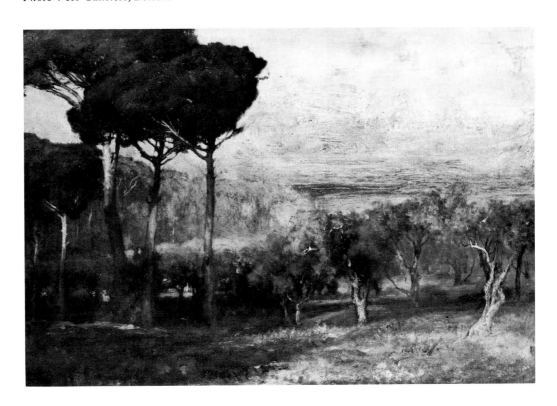

49. *Italian Landscape.* 1872 (?). Oil on canvas, 26½ x 42¾ inches.
Courtesy, Museum of Fine Arts, Boston; Bequest of Nathaniel T. Kidder.

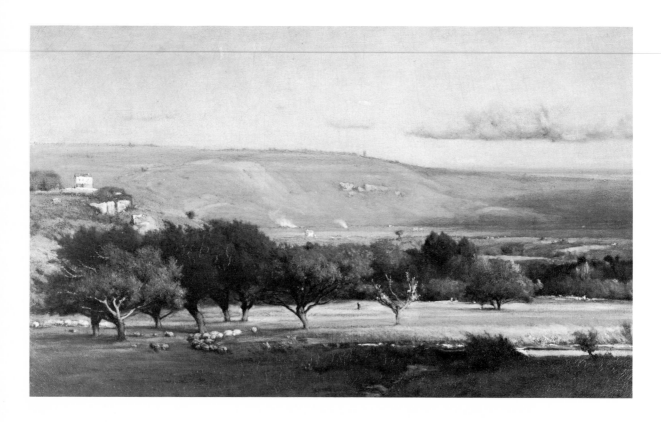

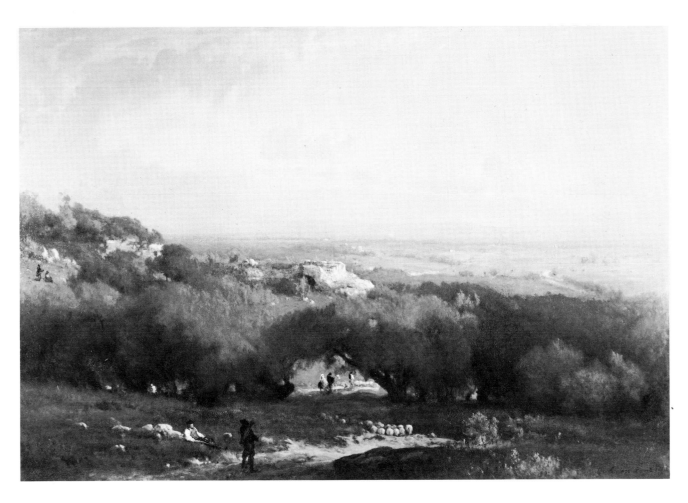

50. *The Alban Hills.* 1873. Oil on canvas, 30⅞ x 45¹⁄₁₆ inches.
Worcester Art Museum, Worcester, Massachusetts.

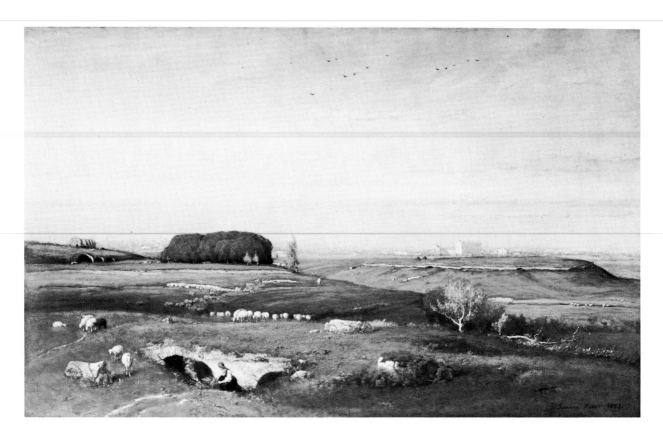

51. *In the Roman Campagna.* 1873. Oil on panel, 26 x 43 inches.
City Art Museum of St. Louis, St. Louis, Missouri.

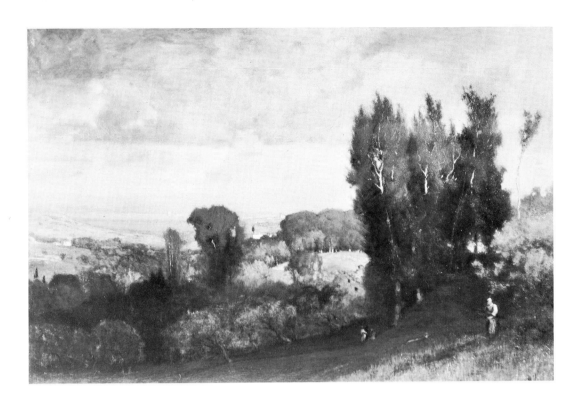

52. *The Olives.* 1873. Oil on canvas, 20 x 30 inches.
The Toledo Museum of Art, Toledo, Ohio; Gift of J. D. Robinson, 1930.

53. *Italian Landscape. ca.* 1875. Oil on cradled panel, 9⅝ x 12⅞ inches.
Charles and Emma Frye Art Museum, Seattle, Washington.
Photo Multi-Media Productions, Seattle, Washington.

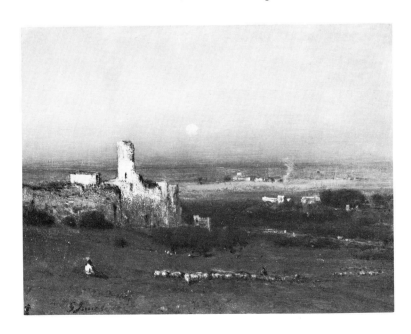

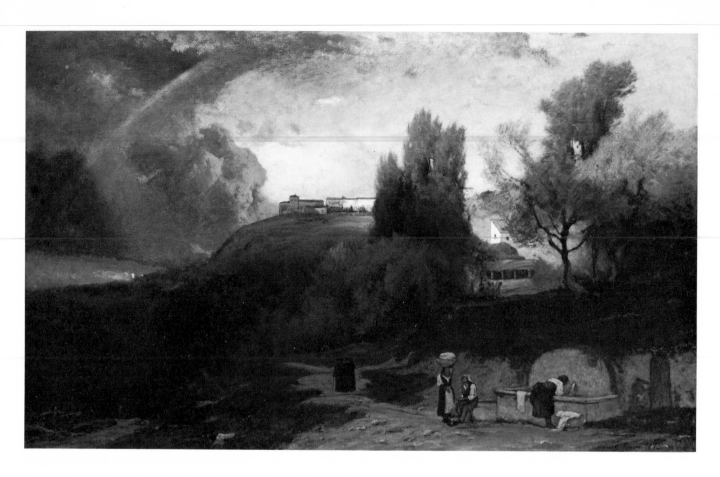

54. *Rainbow over Perugia.* 1875. Oil on canvas, 38½ x 63½ inches.
Courtesy, Museum of Fine Arts, Boston; Gift of Louise W. and Marian R. Case.

55. *Etretat.* 1875. Oil on canvas, 30 x 45 inches.
Courtesy Wadsworth Atheneum, Hartford, Connecticut;
Ella Gallup Sumner and Mary Catlin Sumner Collection.

56. *Evening at Medfield, Massachusetts.* 1875. Oil on canvas, 38 x 63⅛ inches.
The Metropolitan Museum of Art, New York; Gift of George A. Hearn, 1910.

57. *Kearsarge Village.* 1875. Oil on canvas, 16 x 24 inches.
Courtesy, Museum of Fine Arts, Boston; Gift of Miss Mary Thacher in memory of
Mr. and Mrs. Henry C. Thacher and Miss Martha Thacher.

Below
58. *Hillside at Etretat.* 1876. Oil on canvas, 25½ x 38 inches.
The Corcoran Gallery of Art, Washington, D.C.

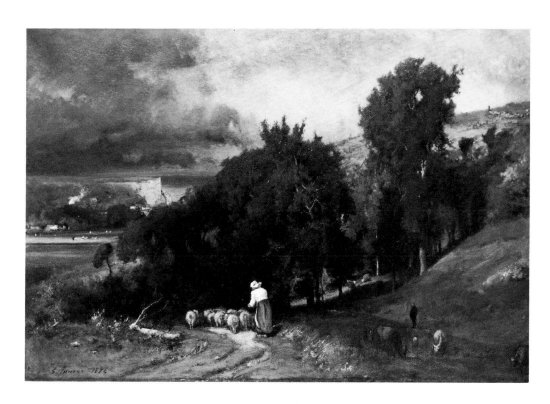

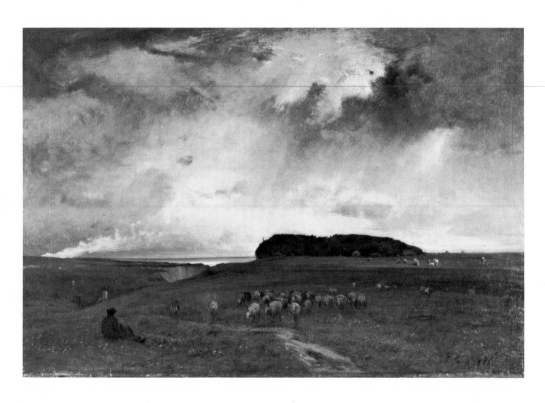

59. *The Storm*. 1876. Oil on canvas, 25⅜ x 38¼ inches.
Courtesy of The Art Institute of Chicago; Edward B. Butler Collection.

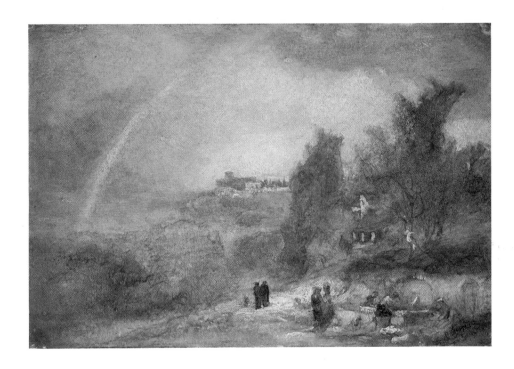

PLATE VI. *Rainbow over Perugia. ca.* 1874. Oil on millboard, 10½ x 15¾ inches. Collection Douglas B. Collins, Longmeadow, Massachusetts.

PLATE VII. *Montclair, New Jersey. ca.* 1885. Oil on canvas, 9 x 15 inches. Heckscher Museum, Huntington, New York.

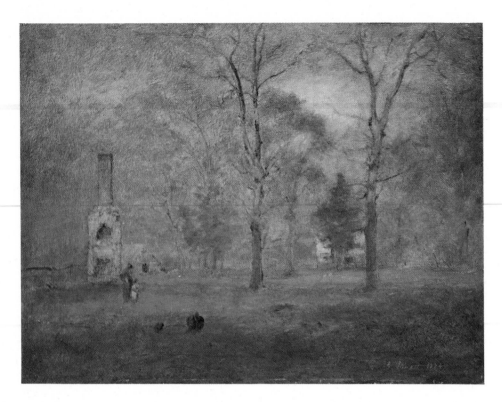

PLATE VIII. *Gray Day, Goochland, Virginia*. 1884. Oil on wood panel, 18 x 24 inches.
The Phillips Collection, Washington, D.C.

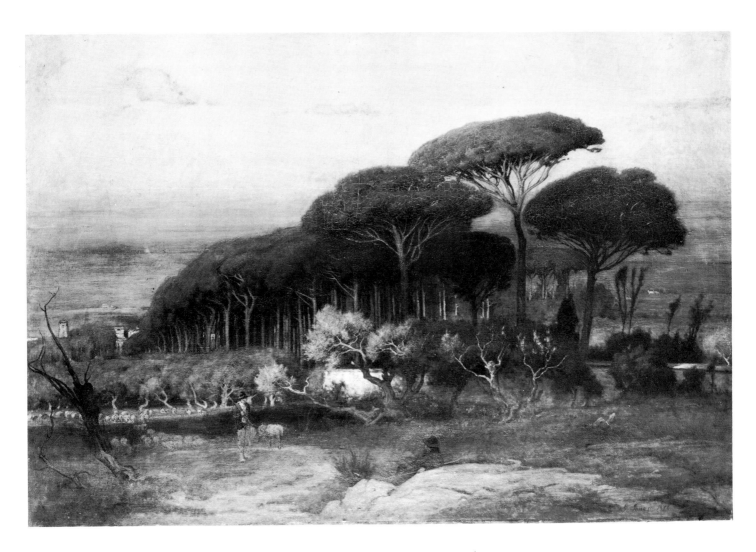

60. *Pine Grove of the Villa Barberini, Albano.* 1876. Oil on canvas, 76⅞ x 118⅝ inches.
The Metropolitan Museum of Art, New York; Gift of Lyman G. Bloomingdale, 1898.

61. *The Conway Meadows*. 1876. Oil on canvas, 38 x 63½ inches.
Mount Holyoke College, South Hadley, Massachusetts; Gift of Miss Ellen W. Ayer.

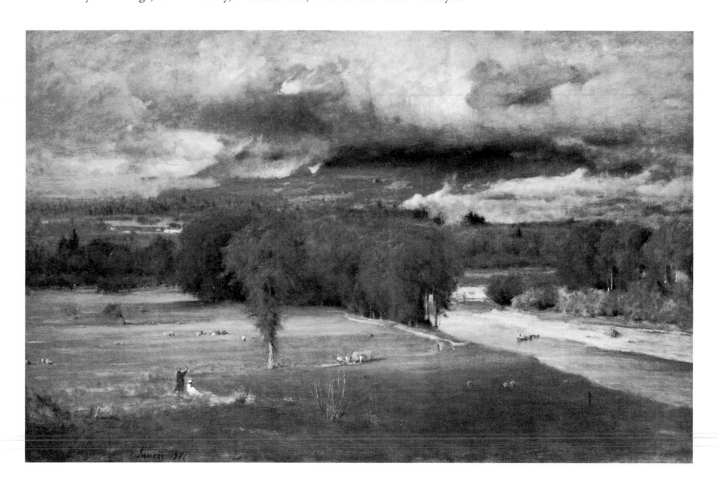

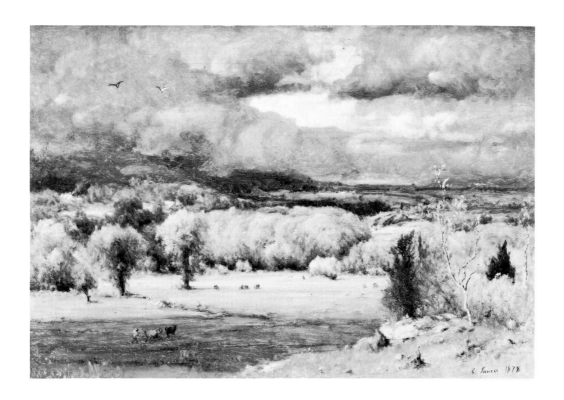

62. *The Coming Storm.* 1878. Oil on canvas, 26 x 39 inches.
Albright-Knox Art Gallery, Buffalo, New York.

63. *The Coming Storm. ca.* 1879. Oil on canvas, 27½ x 42 inches.
Addison Gallery of American Art, Phillips Academy, Andover, Massachusetts.
Photo Andover Art Studio, Andover, Massachusetts.

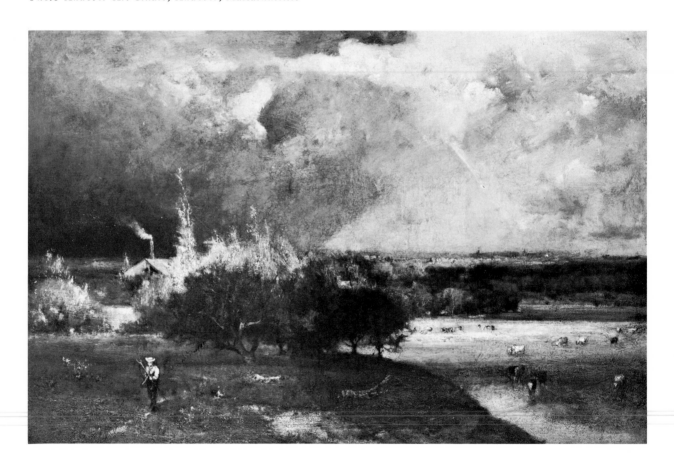

Left

64. *Two Sisters in the Garden.* 1881–83. Oil on canvas, 19¼ x 15¼ inches. Courtesy of The Art Institute of Chicago; Edward B. Butler Collection.

Below

65. *Under the Greenwood.* 1881. Oil on canvas, 36 x 29 inches. Courtesy of North Carolina Museum of Art, Raleigh, North Carolina.

66. *Winter Morning, Montclair*. 1882. Oil on canvas, 30 x 45 inches.
Collection of the Montclair Art Museum, Montclair, New Jersey; Gift of Mrs. Arthur B. Whiteside.
Photo Jean Lange.

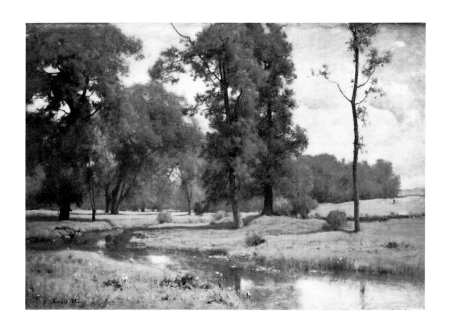

67. *June*. 1882. Oil on canvas, 30¼ x 45 inches. Courtesy of The Brooklyn Museum; Bequest of Mrs. William A. Putnam.

Right
68. *A Short Cut, Watchung Station, New Jersey*. 1883. Oil on canvas, 37¾ x 29 inches. Philadelphia Museum of Art; W. P. Wilstach Collection.

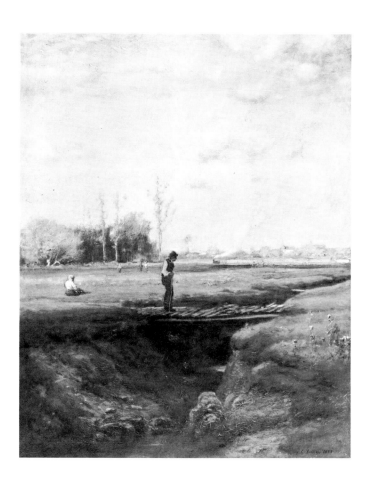

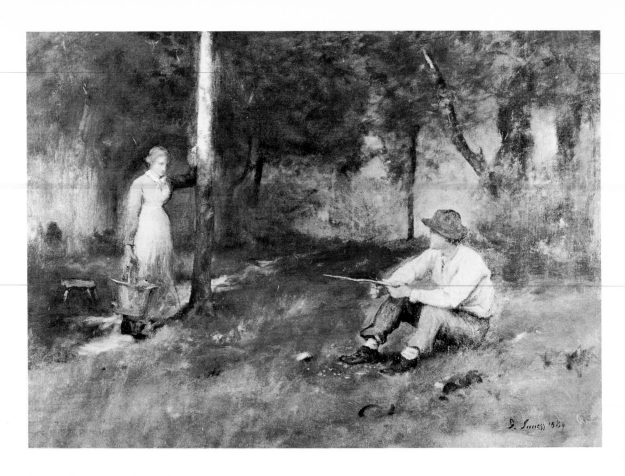

69. *Gossip, Milton,* 1884. Oil on canvas, 20 x 30 inches.
University of Kansas Museum of Art; W. B. Thayer Collection.

70. *Brush Burning*. 1884. Oil on canvas, 20¼ x 30½ inches.
William Rockhill Nelson Gallery of Art—Atkins Museum of Fine Arts, Kansas City, Missouri;
Gift of Mr. and Mrs. Albert R. Jones.

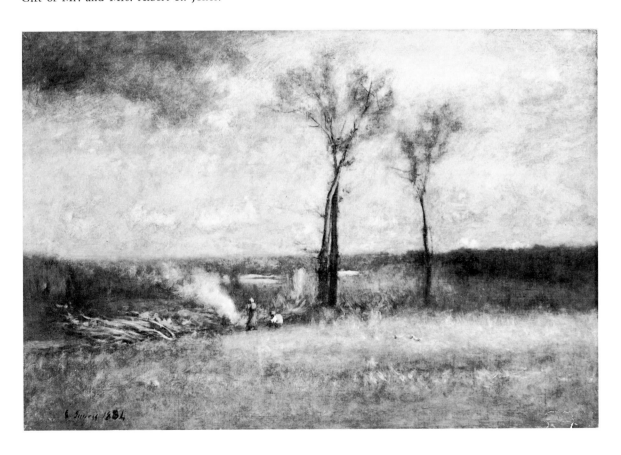

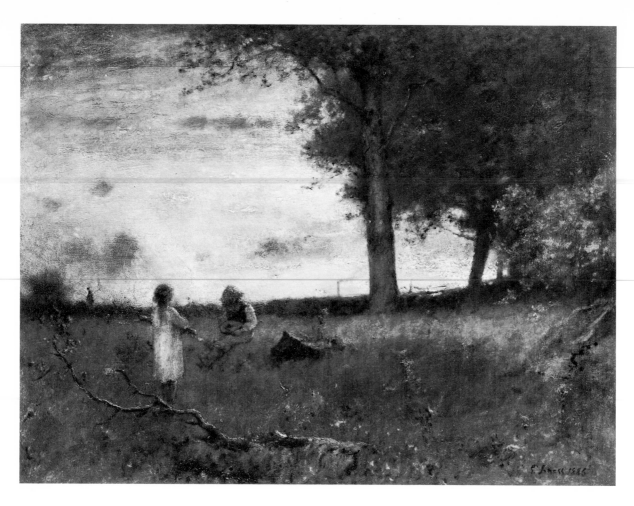

71. *Sunset at Montclair*. 1885. Oil on canvas, 30 x 40 inches.
Private Collection.

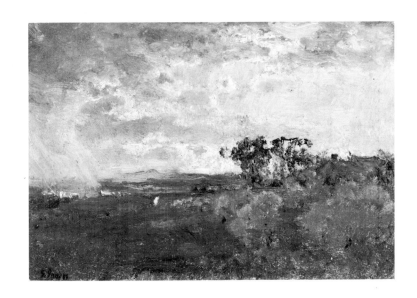

72. *Late Afternoon, Montclair. ca.* 1885. Oil on canvas, 8 x 11½ inches.
New Britain Museum of American Art, New Britain, Connecticut; Harriet Russell Stanley Fund.
Photo E. Irving Blomstrann, New Britain, Connecticut.

Below
73. *October.* 1886. Oil on panel, 20 x 30 inches.
Los Angeles County Museum of Art; Paul Rodman Mabury Collection.

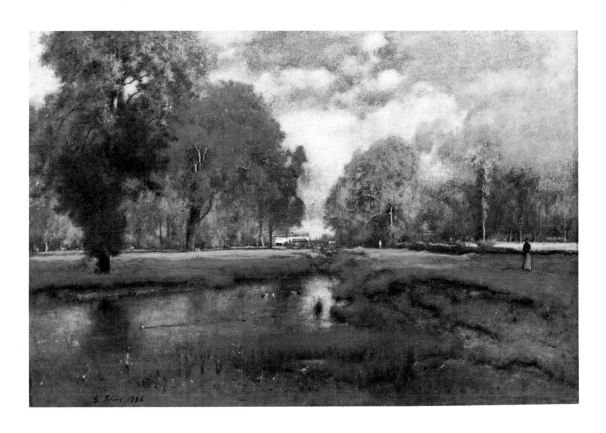

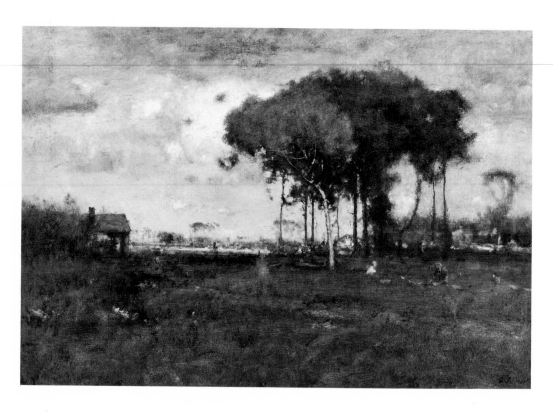

74. *Georgia Pines, Afternoon.* 1886. Oil on canvas, 24 x 36 inches.
Courtesy, Museum of Fine Arts, Boston;
Robert Dawson Evans Collection (Bequest of Mrs. Robert Dawson Evans).

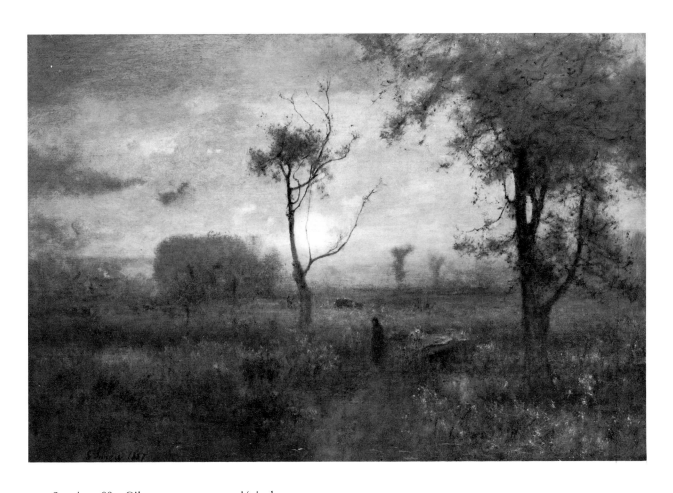

75. *Sunrise*. 1887. Oil on canvas, 30 x 45¼ inches.
The Metropolitan Museum of Art, New York; Anonymous gift in memory of Emil Thiele, 1954.

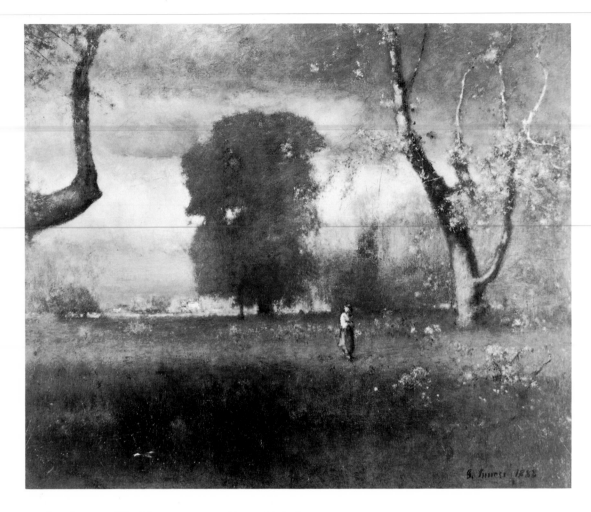

76. *Landscape.* 1888. Oil on canvas, 22⅛ x 27½ inches.
The Cleveland Museum of Art; Gift of the Estate of Charles F. Brush.

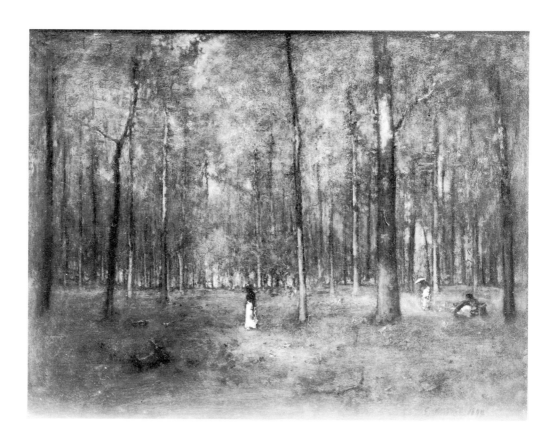

77. Georgia Pines. 1890. Oil on mahogany panel, 17⅝ x 23⅝ inches.
National Collection of Fine Arts (Evans Collection), Smithsonian Institution, Washington, D.C.

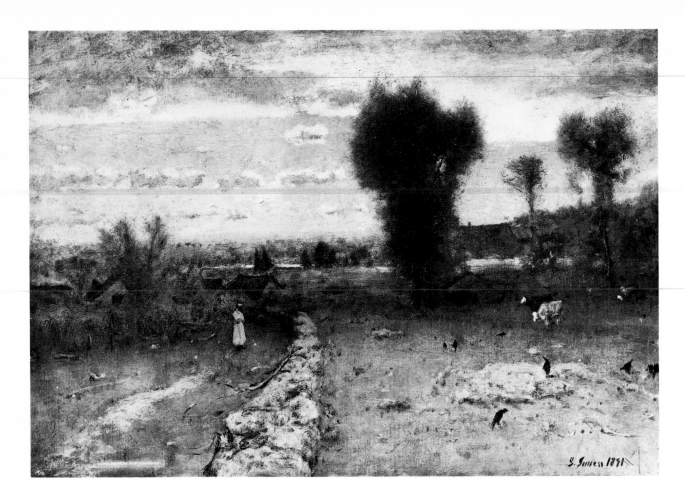

78. *The Clouded Sun.* 1891. Oil on canvas, 30 x 45 inches.
Museum of Art, Carnegie Institute, Pittsburgh, Pennsylvania.

PLATE IX. *October Noon*. 1891. Oil on canvas, 29½ x 44 inches.
Fogg Art Museum, Harvard University, Cambridge, Massachusetts; Grenville L. Winthrop Bequest.

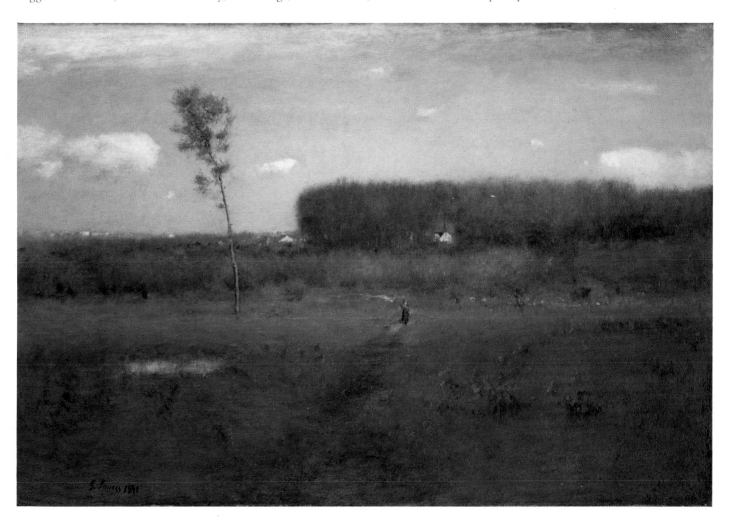

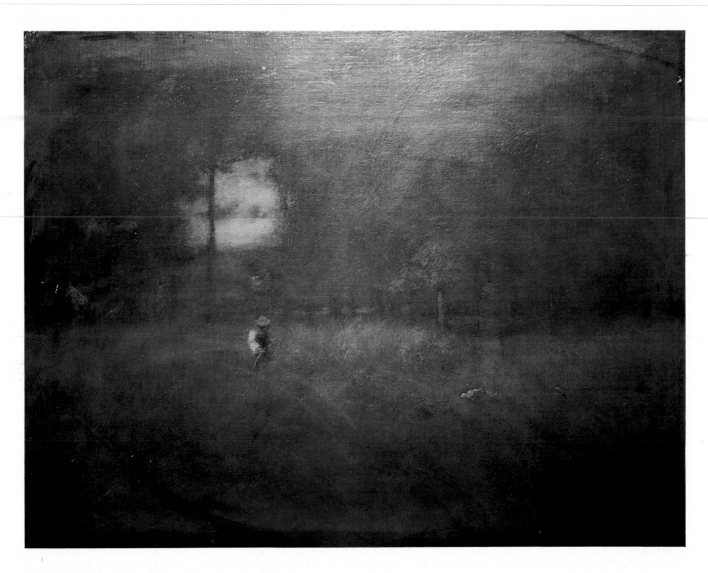

PLATE X. *Across the Meadows, Montclair*. 1893. Oil on canvas, 32 x 42 inches.
Collection of Stouffer's Restaurant, New York.
Photo United Press International (Herb Miller).

79. *The Trout Brook*. 1891. Oil on canvas, 30 x 45 inches.
Collection of The Newark Museum, Newark, New Jersey.
Photo Armen Photographers, Newark, New Jersey.

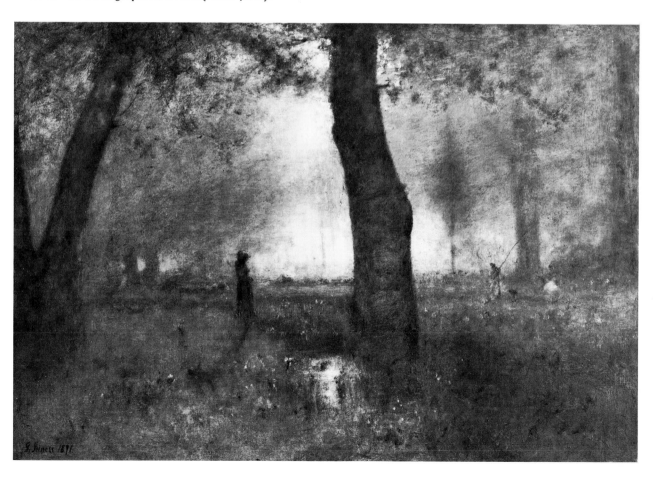

80. *Sunset in the Woods*. 1891. Oil on canvas, 48 x 72 inches.
The Corcoran Gallery of Art, Washington, D.C.

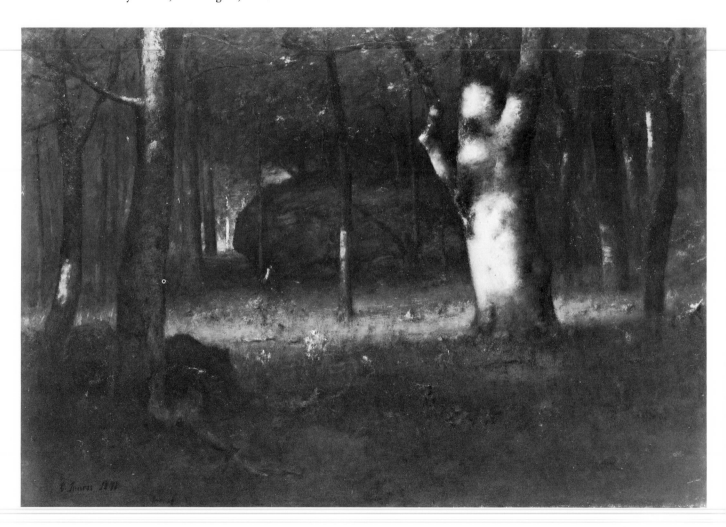

81. *Harvest Moon*. 1891. Oil on canvas, 30 x 45 inches.
The Corcoran Gallery of Art, Washington, D.C.; Bequest of Mabel Stevens Smithers.

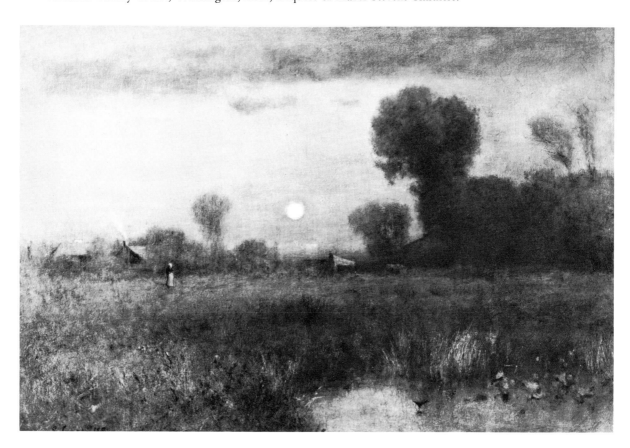

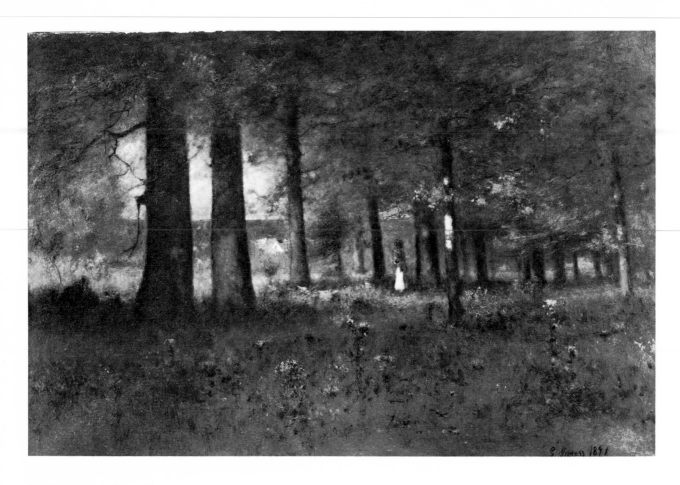

82. *Landscape*. 1891. Oil on canvas, 30 x 45 inches.
Yale University Art Gallery, New Haven, Connecticut; Bequest of Blanche Barclay.

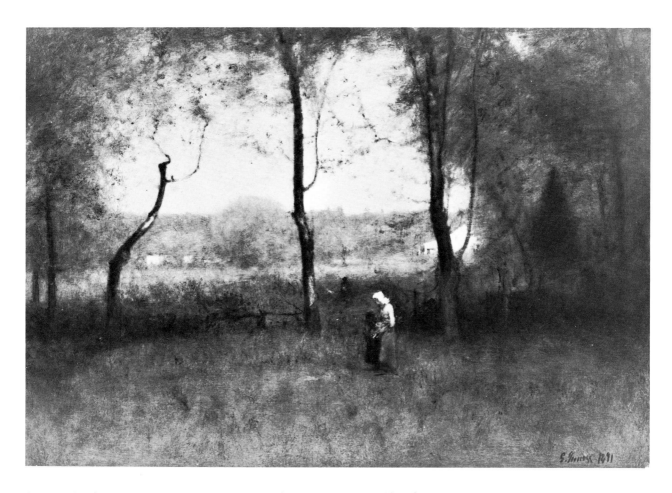

83. *Woodgatherers: Autumn Afternoon.* 1891. Oil on canvas, 30 x 45⅛ inches.
Sterling and Francine Clark Art Institute, Williamstown, Massachusetts.

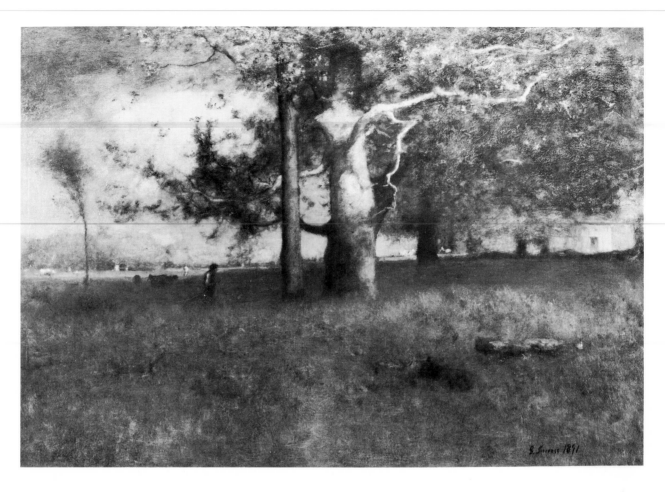

84. *Early Autumn, Montclair*. 1891. Oil on canvas, 30 x 45 inches.
Wilmington Society of the Fine Arts, Delaware Art Center, Wilmington, Delaware.
Photo Lubitsh & Bungarz, Wilmington.

85. *Moonlight, Tarpon Springs, Florida.* 1892. Oil on canvas, 30 x 45 inches.
The Phillips Collection, Washington, D.C.
Photo Victor Amato, Washington, D.C.

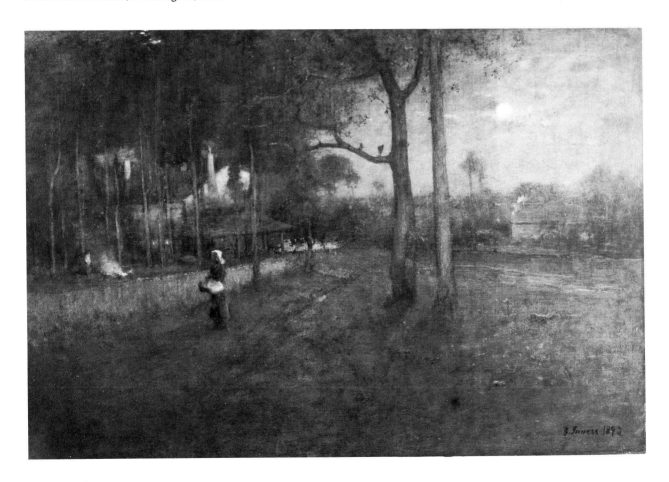

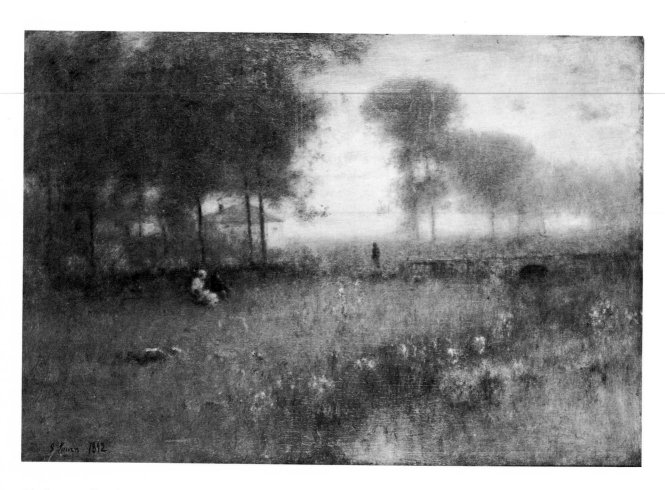

86. *Summer Evening, Montclair*. 1892. Oil on canvas, 30 x 45 inches.
Private Collection.

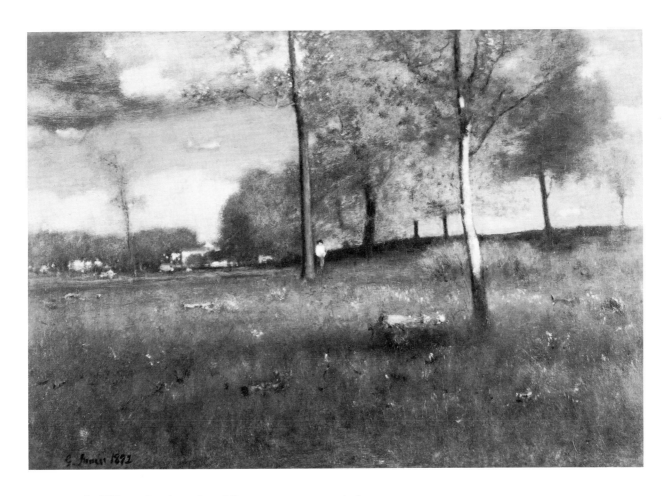

87. *Near the Village, October.* 1892. Oil on canvas, 30 x 45 inches.
Cincinnati Art Museum, Cincinnati, Ohio; Gift of Emilie L. Heine.

88. *Interior of a Wood. ca.* 1893. Oil on canvas, 25 x 30 inches.
Collection Douglas B. Collins, Longmeadow, Massachusetts.
Photo Nathan Rabin, New York.

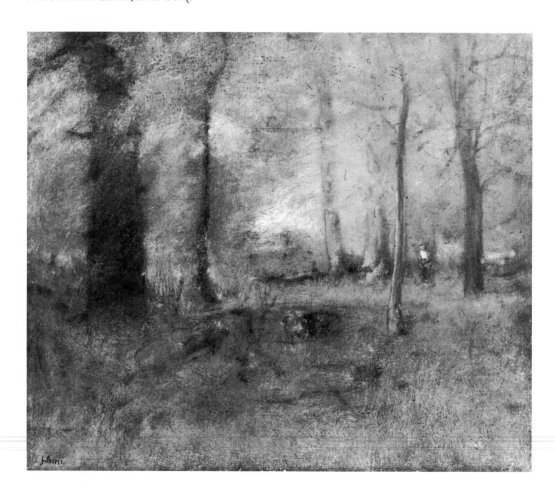

89. *The Home of the Heron.* 1893. Oil on canvas, 30 x 45 inches.
Courtesy of The Art Institute of Chicago; Edward B. Butler Collection.

90. *Old Farm, Montclair.* 1893. Oil on canvas, 30½ x 50½ inches.
William Rockhill Nelson Gallery of Art—Atkins Museum of Fine Arts, Kansas City, Missouri; Nelson Fund.

91. *Autumn Landscape. ca.* 1894. Oil on canvas, 24 x 36 inches.
Art Gallery, University of Notre Dame, Notre Dame, Indiana.

92. *California*. 1894. Oil on canvas, 60 x 48 inches.
The Union League Club, New York.
Photo Frick Art Reference Library, New York.

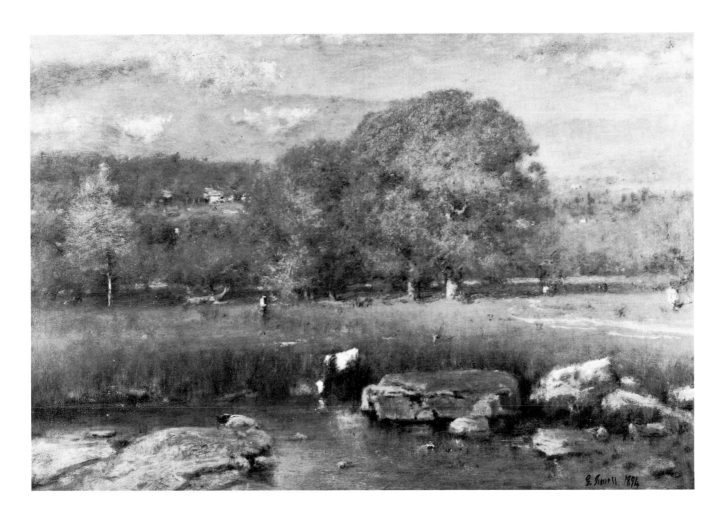

93. *Red Oaks*. 1894. Oil on canvas, 35⅜ x 54 inches.
Santa Barbara Museum of Art, Santa Barbara, California; Preston Morton Collection.
Photo Karl Obert, Santa Barbara.

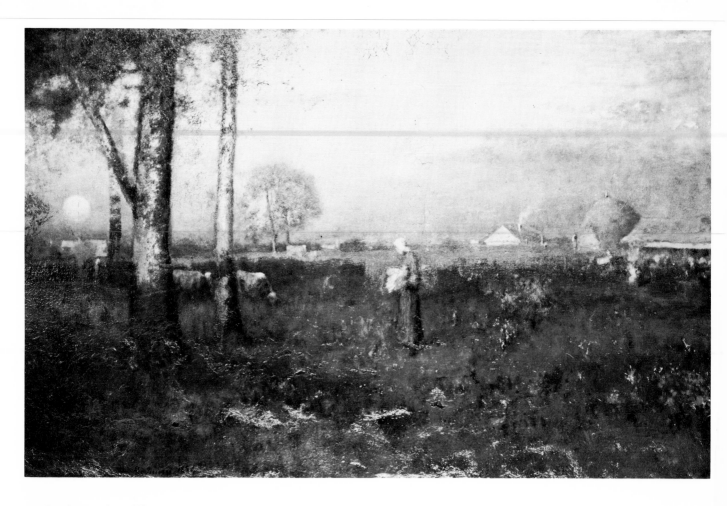

94. *Sundown.* 1894. Oil on canvas, 43¼ x 68½ inches.
National Collection of Fine Arts (Evans Collection), Smithsonian Institution,
Washington, D.C.

NOTES

BIBLIOGRAPHY

INDEX

NOTES

1. See, for example, E. P. Richardson, *Painting in America* (New York: Crowell, 1956); James Thomas Flexner, *That Wilder Image* (Boston and Toronto: Little, Brown, 1962); and most recently, Barbara Novak, *American Painting of the Nineteenth Century* (New York: Praeger, 1969).

2. "Art and Artists in New York (No. 13)," *The Independent,* June 9, 1881.

3. *The Independent,* December 22, 1888.

4. *New York Evening Post,* January 5, 1895.

5. Hamlin Garland, writing on Impressionism in 1894, the year of Inness's death, gives a perfect example of this: "I walked through the loan exhibition [at the 1893 World's Columbian Exposition in Chicago] with a man who cared nothing for precedent—a keen, candid man; and I afterward visited the entire gallery with a painter—a strong and earnest man, who had grown out of the grey-black-and-brown method.

"Both these men shook their heads at Inness, Diaz, Corot, Troyon, Rousseau, and Millet. The painter said, a little sadly, as if surrendering an illusion, 'They do not represent nature to me any more. They're all too indefinite, too weak, too lifeless in shadow. They reproduce beautifully, but their color is too muddy and cold."

"The other man was not even sad. He said, 'I don't like them—that's all there is about it. I don't see nature that way. Some of them are decorative, but they are not nature. I prefer Monet or Hassam or the Norwegians.'" From Hamlin Garland, *Crumbling Idols,* ed. Jane Johnson (Cambridge, Mass.: Harvard University Press, 1960), p. 106.

6. Quoted in George C. Calvert, "George Inness; Painter and Personality," *Bulletin of the Art Association of Indianapolis, Indiana. The John Herron Art Institute,* XII (November, 1926), 49.

7. *Ibid.,* p. 53.

8. Elliott Daingerfield, "George Inness," *The Century,* XCV (1917), 71.

9. "Mr. Inness on Art-Matters," *The Art Journal,* n.s. V (1879), 71.

10. The date of his birth and other facts of his early life are found in George W. Sheldon, "George Inness," *Harper's Weekly,* XXVI (April 22, 1882), 246.

11. Alfred Trumble, *George Inness, N.A., A Memorial of the Student, the Artist, and the Man* (New York: The Collector, 1895), p. 21. John William Inness is absent only from the 1825–26 and 1826–27 New York City directories.

12. *Elizabethtown Gazette,* August 8, 1820, quoted in Elmer T. Hutchinson, "Union Hall Hotel, Elizabethtown, New Jersey," *Proceedings of the New Jersey Historical Society,* LXIV (1946), 71.

13. Sheldon, "George Inness," *Harper's Weekly,* p. 246.

14. Letter to S. R. Koehler, New York, September, 1879 (Print Room, Museum of Fine Arts, Boston).

15. Letter to S. R. Koehler, New York, September 27, 1879 (Print Room, Museum of Fine Arts, Boston).

16. Letter to Ripley Hitchcock, Goochland Courthouse, Goochland, Virginia, March 23, 1884 (Montclair Art Museum, Montclair, New Jersey). This is the major and most extensive autobiographical document.

17. Sheldon, "George Inness," *Harper's Weekly,* and letter to Ripley Hitchcock.

18. Letter to Ripley Hitchcock. The first public mention of his illness seems to have been in Henry T. Tuckerman, *Book of the Artists* (New York: Putnam, 1867; reprinted, New York: James F. Carr, 1966), p. 532.

19. Letter to Edward Gay, November, 1885 (Gay Papers, Archives of American Art, Washington, D.C.).

20. Elizabeth McCausland, *George Inness, An American Landscape Painter, 1825–1894* (Springfield, Mass.: The George Walter Vincent Smith Art Museum, 1946), p. 10.

21. George Inness, Jr., *Life, Art, and Letters of George Inness* (New York: The Century Co., 1917).

22. See Mary Bartlett Cowdrey, ed., *National Academy of Design Exhibition Record, 1826–1860,* 2 vols. (New York: Printed for The New-York Historical Society, 1943).

23. See, for example, the chronology in LeRoy Ireland, *The Works of George Inness. An Illustrated Catalogue Raisonné* (Austin: University of Texas Press, 1965), p. 445.

24. Sheldon, "George Inness," *Harper's Weekly,* p. 246.

25. Letter to Ripley Hitchcock.

26. *The Literary World,* I (1847), 347.

27. *Ibid.,* III (1848), 328.

28. Letter of February 23, 1849 (American Art-Union Papers, The New-York Historical Society).

29. Letter to Ripley Hitchcock.

30. Inness, Jr., *Life,* 21.

31. Quoted in Trumble, *George Inness,* p. 23.

32. "American Artists: George Inness," *Harper's Weekly,* XI (July 13, 1867), 433.

33. "His Art His Religion," *New York Herald,* August 12, 1894.

34. Sheldon, "George Inness," *Harper's Weekly,* p. 246.

35. Montgomery Schuyler, "George Inness: The Man and His Work," *Forum* XVIII (November, 1894), 303.

36. George W. Sheldon, "Characteristics of George Inness," *The Century*, n.s. XXVII (February, 1895), 530.

37. Schuyler, "George Inness," *Forum*, p. 305.

38. The date usually given is 1850 (see Ireland, *Works*, p. 445). Schuyler, "George Inness," *Forum*, p. 305, says the trip was made in 1851, and he may be correct, for as late as December 14 of the previous year, the Art-Union received a letter from Inness concerning the delivery of some paintings (American Art-Union Papers, The New-York Historical Society).

39. Joshua C. Taylor, *William Page: The American Titian* (Chicago: University of Chicago Press, 1957), p. 106 and note 20.

40. Samuel Gray Ward Papers, Houghton Library, Harvard University, Cambridge, Mass. For Ward, see Robert B. Shaffer, "Emerson and His Circle," *Journal of the Society of Architectural Historians*, VII (July-December, 1948).

41. The painter Eastman Johnson, writing from The Hague, October 18, 1853, told what the end of the Art-Union meant to American artists: " . . . [it] has withdrawn indispensible assistance & has left them no possible resource upon which they can rely for the exhibition & possible sale of their pictures." Letter to Andrew Warner, American Art-Union Papers, The New-York Historical Society, quoted in E. Maurice Bloch, "The American Art-Union's Downfall," *The New-York Historical Society Quarterly*, XXXVII (October, 1953), 358.

42. Royal Cortissoz, *American Artists* (New York: Charles Scribner's Sons, 1923), p. 113.

43. Schuyler, "George Inness," *Forum*, p. 303.

44. For instance, Royal Cortissoz said, "The paintings of his youth bore the marks of the Hudson River School" (*American Artists*, p. 113). Frederick S. Lamb wrote, "That Inness should have fallen under the influence of the Hudson River School was only natural." ("Reminiscences of George Inness," *The Art World*, I [January, 1917], 251.) And an obituary writer said that ". . . in his early days [he was] addicted to the mannerisms of the old Hudson River School." (*The Critic*, XXV [1894], 97.)

45. *The Knickerbocker Magazine*, XXIX (June, 1847), 570.

46. *The Literary World, I* (1847), 304.

47. *Ibid., III* (1848), 328.

48. *The Knickerbocker Magazine,* XXXIII (May, 1849), 468.

49. Letter to Ripley Hitchcock.

50. *New York Tribune,* May 1, 1852.

51. *The Literary World,* X (May 8, 1852), 332.

52. *The Knickerbocker Magazine,* XLII (July, 1853), 96.

53. Quoted in Elliott Daingerfield, *George Inness: The Man and his Art* (New York: Frederic Fairchild Sherman, 1911), p. 15.

54. *The Knickerbocker Magazine,* XLV (May, 1855), 533.

55. *The Independent,* December 27, 1860.

56. For further observations on this painting and on Inness's relation to the Hudson River School, see my article "George Inness and the Hudson River School: *The Lackawanna Valley,*" *The American Art Journal*, II, No. 2 (November, 1970), 36–57.

57. Ireland, *Works,* dates this painting (No. 242 in his *catalogue raisonné*) at 1862–64, but it is much more likely a work of the middle 1850's.

58. Tuckerman, *Book of the Artists,* p. 527.

59. "A Painter on Painting," *Harper's New Monthly Magazine,* LVI (1878), 459.

60. Inness, Jr., *Life,* p. 36; Schuyler, "George Inness," *Forum,* p. 306.

61. "Inness has taken the studio recently occupied by Coleman, in Montague place [*sic*], Brooklyn." (*New York Tribune,* March 31, 1860.) His address in the Academy catalogue is 137 Montague Street.

62. *New York Tribune,* September 29, 1860.

63. *The Crayon,* VII (May, 1860).

64. *New York Evening Post,* May 25, 1860.

65. Schuyler, "George Inness," *Forum,* p. 307.

66. *New York Evening Post,* November 20, 1863.

67. George Junior's implied explanation for the repainting is confused but quite literally colorful; he says it fell on his father while it was still wet. But *The Sign of Promise* was, despite this accident, finished and exhibited in 1863, and only later repainted. Its size was "about 7 x 10" feet (*New York Evening Post,* March 3, 1863); *Peace and Plenty* is 77 x 110 inches.

68. Information is from M. H. Greene, "Raritan Bay Union, Eagleswood, N.J.," *Proceedings of the New Jersey Historical Society,* LXVIII (January, 1950), 1–20.

69. The most famous of Inness's pupils at Eagleswood was Louis Comfort Tiffany.

70. The *New York Evening Post,* May 12, 1865, said in an Academy review, "The sunset in the north gallery (198) shows the influence of Page—a tyrannical and consistent theorist, who subjects all by his logic, save those that rely on their perceptions and live out of doors. We are sorry to find Inness bowing before a power which has ceased to be productive of living art, and which draws its life from the past."

71. *A View on the Hudson,* "from the collection of Rev. H. W. Beecher," was in the first artists' reception at Dodworth's Hall, Brooklyn (*New York Evening Post,* March 23, 1860).

72. Montgomery Schuyler, Obituary, *Harper's Weekly,* XXXVIII (August 11, 1894), 787.

73. Henry Ward Beecher, "Hours of Exhaltation," *Eyes and Ears* (Boston: Ticknor and Fields, 1862), pp. 35, 37.

74. Beecher, "The Office of Art," *ibid.,* pp. 226–67.

75. Beecher, "Art Among the People," *ibid.,* pp. 265–66.

76. See his 1865 letter to John Rogers, quoted in David H. Wallace, *John Rogers, The People's Sculptor* (Middletown, Conn.: Wesleyan University Press, 1967), p. 135.

77. Henry Ward Beecher, "Introductory Letter," in Charles Dudley Warner, *My Summer in a Garden* (Boston: J. R. Osgood & Co., 1870), p. 3.

78. George W. Sheldon, *American Painters* (New York: D. Appleton & Co., 1879), p. 30; Inness, Jr., *Life,* p. 245.

79. *New York Evening Post,* August 19, 1862.

80. *"The Sign of Promise."* By George Inness . . . (New York: Snedecor's Gallery, n.d.), n.p.

81. *New York Evening Post,* June 2, 1863.

82. Quoted in "Pictures on Exhibition," *The New Path,* I (December, 1863), 99.

83. Letter from Boston, unsigned, March 3, 1863.

84. *Atlantic Monthly,* XXXI (January, 1873), 115.

85. *New York Evening Post,* August 8, 1865.

86. "George Inness sailed for Europe on Saturday last," *New York Evening Post,* Monday, May 2, 1870.

87. S. N. C. (Susan N. Carter), "Notes from American Studios in Italy," *Appleton's Journal,* XII (August 8, 1874), 188.

88. In a letter to Mr. Williams, Inness said not only that he was $2,100 in debt to J. C. Hooker, a banker in Rome, but that "hope of sale [*sic*] to arriving Americans this season is so small that I trust but little to it." (Rome, January 8, 1874, Gratz Collection, Historical Society of Philadelphia.)

89. Inness, Jr., *Life,* pp. 81–82, says his father was "compelled to make a hurried trip back to the States" in 1873 because Williams & Everett, as a result of the 1872 Boston fire, could no longer make their payments to him. He reprints a letter from Inness to his wife written from Liverpool shortly before sailing; he dates it February 13, 1873. He says also that his father, failing to make an arrangement with Williams & Everett, came to terms instead with Doll & Richards, also of Boston. All of this information is perfectly plausible, but it is incorrect. According to the date given for the letter, Inness should have arrived in New York in late February, 1873, yet he is not found among arriving passengers. If the year is changed to 1875, however, the other part of the date conforms with it, for one discovers Inness listed in the New York newspapers as arriving on the *Algeria* thirteen days after the date of the letter. Furthermore, the arrangement with Doll & Richards that George Junior said was made in 1873 was in fact made in 1875, as indicated by an account in the *New York Tribune,* January 20, 1877, of the difficulties to which it subsequently led.

90. See note 70.

91. The agreement is still in the possession of Doll & Richards. A copy was supplied to me by the late Mr. LeRoy Ireland, by way of Mr. Morton Vose, to all of whom I am extremely grateful.

92. *New York Tribune,* January 20, 1877.

93. See Theodore F. Jones, *New York University 1832–1932* (New York: New York University Press, 1933), Appendix A, "Non-Academic Tenants of the Old Building at Washington Square," pp. 393–98. Inness's studio is illustrated in S. G. W. Benjamin, *Our American Artists, For Young People,* second series (Boston: D. Lothrop & Co., 1879[?]), p. 38.

94. *New York Times,* April 10, 1878. To my knowledge, none of these poeticized frames survive. Examples of Inness's poetry are provided by Inness, Jr., *Life,* pp. 97–98, 101–6, and Sheldon, "George Inness," *Harper's Weekly,* pp. 244–45.

95. Cropsey letter to John P. Ridner, Gaylord's Bridge, Conn., August 24, 1845 (Boston Public Library).

96. "American Artists," *Harper's Weekly,* p. 433.

97. "It is thought by many persons—good judges for the most part, and among

them many artists—that Mr. Inness is the very best of landscape-painters." *Appleton's Journal*, XIX (1878), 469.

98. Philip Gilbert Hamerton, "English and American Painting at Paris in 1878," Part II, *International Review*, VI (1879), 555–56.

99. Charles De Kay ("Henry Eckford"), in *The Century*, n.s. II (May, 1882), 57–64. In addition to offering a sensitive appraisal of Inness, De Kay was one of the few to appreciate and the first to write at length about Albert Pinkham Ryder ("A Modern Colorist," *The Century*, XL [June, 1890], 250–59).

100. Sutton called it "the display which aided to establish him in his present position." *New York Herald*, March 10, 1889.

101. S. C. G. Watkins, *Reminiscences of Montclair* (New York: Putnam, 1929), p. 116.

102. Quoted in Stanwood Cobb, "Reminiscences of George Inness by Darius Cobb," *Art Quarterly*, XXVI (Summer, 1963), 236.

103. "A Painter on Painting," *Harper's New Monthly Magazine*, p. 461.

104. *New York Evening Post*, April 25, 1874.

105. *New York Tribune*, April 26, 1874.

106. *New York Times*, April 17, 1875.

107. *The Independent*, April 25, 1878.

108. *New York Times*, April 10, 1878.

109. *New York Tribune*, April 2, 1878.

110. "Mr. Inness on Art-Matters," *The Art Journal*, p. 377.

111. *New York Herald*, August 22, 1894.

112. Letter to "Editor Ledger," Tarpon Springs, Florida, quoted in Inness, Jr., *Life*, pp. 169, 173.

113. "A Painter on Painting," *Harper's New Monthly Magazine*, p. 459.

114. *New York Times*, May 29, 1865; *New York Tribune*, April 10, 1878.

115. *New York Times*, April 10, 1878.

116. It is remarkable how many of Lawrence Gowing's observations in his recent re-evaluation of Turner (*Turner: Imagination and Reality* [New York: The Museum of Modern Art, 1966]) can easily be applied to Inness.

117. D. Maitland Armstrong, *Day Before Yesterday. Reminiscences of a Varied Life* (New York: Charles Scribner's Sons, 1920), p. 288.

118. De Kay in *The Century*, p. 63.

119. *The Century*, XIV (June, 1877), 264.

120. *New York Times*, March 30, 1879.

121. *New York Tribune*, April 1, 1879.

122. *New York Evening Post*, April 2, 1881.

123. Quoted in Rev. Louis L. Noble, *The Life and Works of Thomas Cole*, ed. Elliot S. Vesell (Cambridge, Mass.: Harvard University Press, 1964), p. 82.

124. *New York Tribune*, March 30, 1878.

125. S. G. W. Benjamin, "Tendencies of Art in America," *American Art Review*, I (1880), 109.

126. Quoted in Inness, Jr., *Life*, pp. 150–51, 155.

127. *New York Tribune*, August 20, 1894.

128. *New York Times*, August 19, 1894.

129. *Atlantic Monthly,* XXXI (1873).

130. Tuckerman, *Book of the Artists,* p. 527.

131. James Jackson Jarves, *The Art-Idea,* ed. Benjamin Rowland, Jr. (Cambridge, Mass.: The Belknap Press of Harvard University Press, 1960), p. 195.

132. Schuyler, Obituary, *Harper's Weekly,* p. 787.

133. "American Painters—George Inness," *The Art Journal,* n.s. II (1876), 84.

134. "A Painter on Painting," *Harper's New Monthly Magazine,* p. 461.

135. Letter to Ripley Hitchcock.

136. Letters to the *New York Herald, New York Times,* and *New York Tribune,* March 6, 1889.

137. *New York Herald,* March 9, 1889.

138. De Kay, in *The Century,* p. 62.

139. *Ibid.,* p. 63.

140. *Ibid.*

141. *Ibid.*

142. Elliott Daingerfield, "Inness—Genius of American Art," *Cosmopolitan,* LV (1913), 525.

143. Quoted in Sheldon, "George Inness," *Harper's Weekly,* p. 244.

144. Albany Institute of History and Art, Albany, New York. I am grateful to David Huntington for bringing this to my attention.

145. "A Painter on Painting," *Harper's New Monthly Magazine,* p. 460.

146. "Mr. Inness on Art-Matters," *The Art Journal,* p. 374.

147. *Ibid.,* p. 377.

148. "A Painter on Painting," *Harper's New Monthly Magazine,* p. 461.

149. De Kay, in *The Century,* p. 60.

150. Daingerfield, "George Inness," *The Century,* p. 71.

151. A Montclair acquaintance, S. C. G. Watkins, said, "I have seen him stand in front of a picture and paint with every nerve under tension, every muscle under strain, [and] . . . strain his eyes at the picture with such intensity that they would bulge from his head and his hair fairly stand on end." (*Reminiscences of Montclair,* p. 110). His pupil Arthur T. Hill said "his attack upon the canvas . . . was literally an attack." ("Early Recollections of George Inness and George Waldo Hill," *New Salmagundi Papers. Series of 1922* [New York, 1922], p. 110.)

152. Hill, "Early Recollections," *New Salmagundi Papers,* p. 114.

153. "Mr. Inness on Art-Matters," *The Art Journal,* p. 375.

154. Quoted in Inness, Jr., *Life,* p. 64.

155. "Mr. Inness on Art-Matters," *The Art Journal,* p. 376.

156. *Ibid.,* p.377.

157. Quoted in Sheldon, *American Painters,* p. 34.

158. Letter to Ripley Hitchcock.

159. "A Painter on Painting, *Harper's New Monthly Magazine,* p. 458.

160. "Mr. Inness on Art-Matters," *The Art Journal,* p. 376.

161. Daingerfield, "Inness—Genius of American Art," *Cosmopolitan,* p. 525.

162. Quoted in M. Block, *The New Church in the New World* (New York: H. Holt and Co., 1932), p. 12.

163. Emanuel Swedenborg, *Divine Love and Wisdom,* para. 321.

164. *Ibid.*

165. Theophilus Parsons, *Outlines of the Religion and Philosophy of Swedenborg* (New York: New Church Board of Publication, 1903.), p. 84.

166. Emanuel Swedenborg, *True Christian Religion,* paras. 24(5), 75(3)(iii).

167. Parsons, *Outlines of the Religion and Philosophy of Swedenborg,* p. 87.

168. Swedenborg, *Divine Love and Wisdom,* para. 7.

169. Swedenborg, *True Christian Religion,* para. 29.

170. Emanuel Swedenborg, *Arcana Cœlestia,* para. 3341.

171. *Ibid.,* para. 4530.

172. "Some Living American Painters. Critical Conversations by Howe and Torrey," *Art Interchange,* XXXII (April, 1894), 102.

173. Cropsey letter to John P. Ridner.

174. Flexner, *That Wilder Image,* Chapter 17.

175. Maurice Denis, *Theories: 1890–1910,* quoted in Elizabeth Holt, *From the Classicists to the Impressionists: A Documentary History of Art and Architecture in the Nineteenth Century* (New York: Doubleday, Anchor Books, 1966), p. 509.

176. Letter to "Editor Ledger," quoted in Inness, Jr., *Life,* p. 169.

SELECTED BIBLIOGRAPHY

"American Artists: George Inness." *Harper's Weekly*, XI (July 13, 1867).

"American Painters—George Inness." *The Art Journal*, n.s. II (1876).

ARMSTRONG, D. MAITLAND. *Day Before Yesterday. Reminiscences of a Varied Life.* New York: Charles Scribner's Sons, 1920.

BENJAMIN, S. G. W. *Our American Artists, For Young People.* Second series. Boston: D. Lothrop & Co., 1879 [?].

BUCHANAN, CHARLES L. "Inness and Winslow Homer." *The Bookman*, XLVII (July, 1918).

CALVERT, GEORGE C. "George Inness; Painter and Personality." *Bulletin of the Art Association of Indianapolis. The John Herron Art Institute*, XIII (November, 1926).

CIKOVSKY, NICOLAI, JR., "George Inness and the Hudson River School: *The Lackawanna Valley*," *The American Art Journal*, II, No. 2 (November, 1970).

COBB, STANWOOD. "Reminiscences of George Inness by Darius Cobb." *Art Quarterly*, XXVI (Summer, 1963).

DAINGERFIELD, ELLIOTT. *Fifty Paintings by George Inness.* New York: Frederic Fairchild Sherman, 1913.

————. *George Inness, The Man and his Art.* New York: Frederic Fairchild Sherman, 1911.

————. "George Inness." *The Century*, XCV (1917).

————. "A Reminiscence of George Inness." *The Monthly Illustrator*, III (March, 1895).

DE KAY, CHARLES ("Henry Eckford"). "George Inness." *The Century*, n.s. II (May, 1882).

DOWNES, WILLIAM HOWE. "George Inness." *Dictionary of American Biography*, IX. New York: Charles Scribner's Sons, 1932.

FLEXNER, JAMES T. *That Wilder Image.* Boston and Toronto: Little, Brown, 1962.

GEARN, HELEN VER NOOY. "George Inness—1825–1894." *The Historical Society of Newburgh Bay and the Highlands* [Yearbook] (1956).

GERDTS, WILLIAM H., JR. *Painting and Sculpture in New Jersey.* Princeton, N.J.: Van Nostrand, 1964.

HILL, ARTHUR TURNBULL. "Early Recollections of George Inness and George Waldo Hill," *New Salmagundi Papers. Series of 1922.* New York, 1922.

"Some Living American Painters. Critical Conversations by Howe and Torrey." *Art Interchange*, XXXII (April, 1894).

INNES, GEORGE. Letter to Ripley Hitchcock. Privately printed facsimile edition (Mt. Vernon, N.Y.: William Edwin Rudge, 1928). Original letter in the Montclair Art Museum.

[INNES, GEORGE]. "A Painter on Painting." *Harper's New Monthly Magazine*, LVI (1878).

———. "His Art His Religion." *New York Herald*, August 12, 1894.

———. "Mr. Inness on Art-Matters." *The Art Journal*, n.s. V (1879).

———. "Strong Talk on Art," *New York Evening Post*, June 3, 1879.

"The Sign of Promise," by George Inness. Now on Exhibition at Snedecor's Gallery, 768 Broadway, New York (undated).

The Paintings of George Inness (1844–94). Exhibition catalogue. University Art Museum of the University of Texas, December 12, 1965–January 30, 1966 (Austin, 1965).

George Inness of Montclair. Exhibition catalogue. Montclair Art Museum, January 12–February 16, 1964 (Montclair, N.J., 1964).

INNESS, GEORGE, JR. *The Life, Art, and Letters of George Inness*. New York: The Century Co., 1917.

IRELAND, LEROY. *The Works of George Inness. An Illustrated Catalogue Raisonné*. Austin: University of Texas Press, 1965.

LAMB, FREDERICK STYMETZ. "Reminiscences of George Inness." *The Art World*, I (January, 1917).

McCAUSLAND, ELIZABETH. *George Inness, An American Landscape Painter, 1825–1894*. Springfield, Mass.: The George Walter Vincent Smith Art Museum, 1946.

MONKS, JOHN A. S. "A Near View of Inness." *Art Interchange*, XXXIV (June, 1895).

"George Inness." *National Cyclopedia of American Biography*, II. New York: James T. White & Co., 1891.

SCHUYLER, MONTGOMERY. "George Inness: The Man and his Work." *Forum*, XVIII (November, 1894).

———. Obituary. *Harper's Weekly*, XLVII (August 11, 1894).

SHELDON, GEORGE W. *American Painters*. New York: D. Appleton & Co., 1879.

———. "Characteristics of George Inness." *The Century*, n.s. XXVII (February, 1895).

———. "George Inness." *Harper's Weekly*, XXVI (April 22, 1882).

TRUMBLE, ALFRED. *George Inness, N.A., A Memorial of the Student, the Artist, and the Man*. New York: The Collector, 1895.

TUCKERMAN, HENRY T., *Book of the Artists*. New York: Putnam, 1867; reprinted, New York: James F. Carr, 1966.

VAN DYCK, JOHN C. "George Inness." *The Outlook*, LXXIII (March 7, 1903).

WALTON, HENRY B. "The Art Work of the Late George Inness." *Metropolitan Magazine*, IX (May, 1899).

WATKINS, S. C. G. *Reminiscences of Montclair*. New York: Putnam, 1929.

WHEELER, CANDACE. *Yesterdays in a Busy Life*. New York: Harper & Bros., 1918.

INDEX